WATERFALLS OF
WISCONSIN

THE WILD WATERS OF INTRIGUE

TROY HESS

AMERICA
THROUGH TIME®
ADDING COLOR TO AMERICAN HISTORY

America Through Time is an imprint of Fonthill Media LLC
www.through-time.com
office@through-time.com

Published by Arcadia Publishing by arrangement with Fonthill Media LLC
For all general information, please contact Arcadia Publishing:
Telephone: 843-853-2070
Fax: 843-853-0044
E-mail: sales@arcadiapublishing.com
For customer service and orders:
Toll-Free 1-888-313-2665

www.arcadiapublishing.com

First published 2021

Copyright © Troy Hess 2021

ISBN 978-1-63499-370-8

Typeset in Trade Gothic
Printed and bound in England

CONTENTS

ACKNOWLEDGMENTS

I'm thankful for those who held an integral part of my journey in making this possible. To those who rode along and hiked many footsteps, I'm appreciative of your willingness to accompany me. I also extend my gratitude to my family and friends and to those who support my creative endeavors. The encouragement from each of you propels my aspirations into reality! Thank you all very much!

ABOUT THE AUTHOR

TROY HESS is a photographer and rural explorer from northwestern Wisconsin. His diverse array of images often portray thought-provoking imagery. His passion for waterfalls began with a yearning to explore nature. He soon found each adventure was a rejuvenating experience resulting in his pursuit to capture the next intriguing niche. Troy continues his travels to explore and capture these hidden wonderments throughout the upper Midwest.

INTRODUCTION

W hen Wisconsin went on lockdown for the global pandemic, it was the perfect time for me to sort through years of images and assemble them into this medley of photographic memoirs. My objective was to compile a comprehensive collection of Wisconsin's waterfalls as a way for others to experience wide-open nature, free from the confines of crowds. With a glimpse through my lens, discover invaluable insights into the intriguing getaways that will lure your attention.

Wisconsin is not a state synonymous with waterfalls. However, many prevail within the forested regions in the northern part of the state. I often wonder how many waterfalls there are in Wisconsin. This question is not an easy one to answer. When considering natural waterfalls, the height of the drop is often a determining factor. Without getting too technical on classifications, I will mention all known waterfalls, including rapids and notable spillways. Many exhibit modest drops in elevation that some might not consider a waterfall. Nevertheless, each destination offers a unique experience with varying degrees of visual aesthetics.

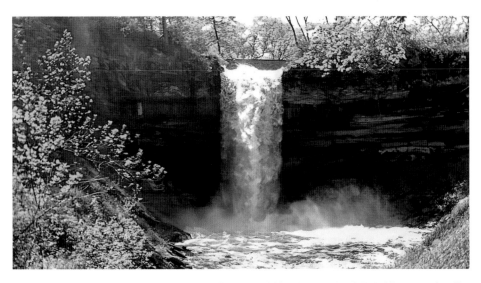

My first snapshot of a waterfall was during the Spring of 2001 at Minnehaha Falls in Minnesota. I realize this is not a Wisconsin waterfall but the first picture I ever took of one. Little did I know, visiting this waterfall would launch my interest in digital photography.

1

CAPTURING THE ESSENCE

After experiencing the thrill of seeing my first waterfall, I knew someday I wanted to find more of them to photograph. Once my photography skills improved, I acquired better imaging equipment to pursue my ambitions. Over the years since, I have spent innumerable hours researching and traveling to many of these destinations.

It was a challenge for me to arrange this into something presentable and determine which photographs to include. I hope my experiences help to convey appreciation and respect for these waterways. I can only hope those who seek these marvels share the same sentiments. The following waterfall images are in alphabetical order. For parks with multiple waterfalls, the name of the park will take precedence. If a waterfall has no name, then the order of the list will proceed by the name of the water.

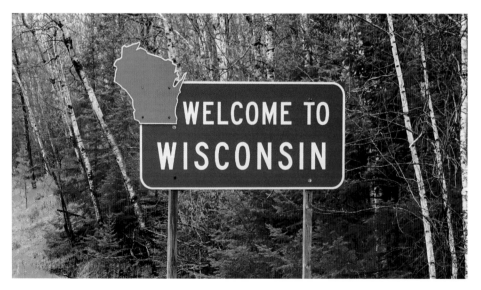

The destinations from here on include images taken with various cameras from over the past decade. To begin this journey, we travel to Amnicon Falls State Park—a sprawling park not far from Lake Superior, where the Amnicon courses through northern Wisconsin.

AMNICON FALLS STATE PARK - UPPER AMNICON FALLS

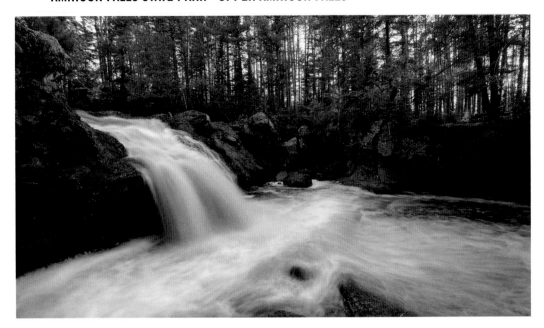

Watching Upper Amnicon Falls is an exhilarating experience. As the water crashes down with an Earth-shaking roar, a delicate mist dissipates through the air. In the late spring of 2018, severe flooding washed away many walkways here at Amnicon Falls State Park.

AMNICON FALLS STATE PARK - LOWER AMNICON FALLS

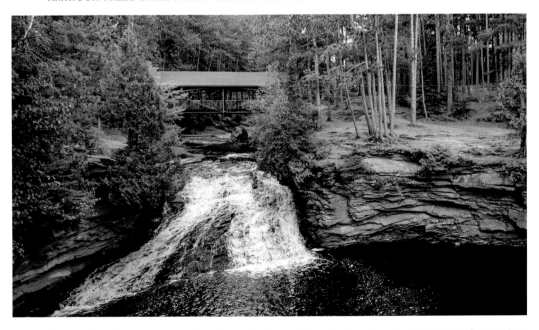

The Amnicon River presents a series of cascades through the park. After the main drop, the river flows under a footbridge where it fans over a steep slope. From here, the Amnicon calmly flows northward to meet with Lake Superior.

AMNICON FALLS STATE PARK - SNAKE PIT FALLS

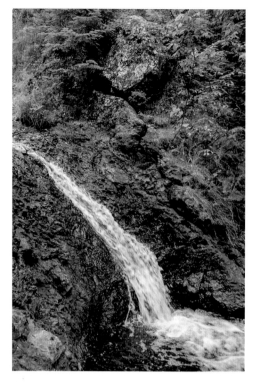

Snake Pit Falls on the upper edge of the park rejoins the main river after its descent.

AMNICON FALLS STATE PARK - NOW & THEN FALLS

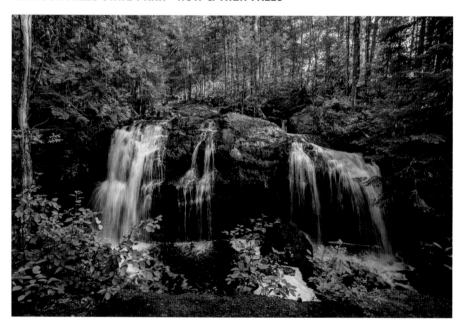

Now & Then Falls is an occasional overflow best viewed after heavy rains. As many times as I have been to this park, this particular waterfall has been dry. After recent flooding, I knew "Now & Then Falls" would be a "Now" versus a "Then." Much to my delight, it was quite a magnificent sight.

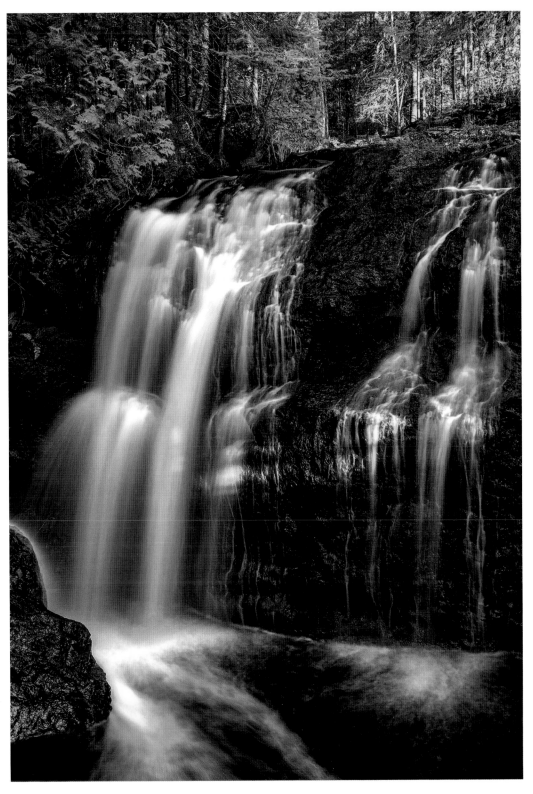

Here is a closer view from down in the narrow trench.

THE APPLE RIVER

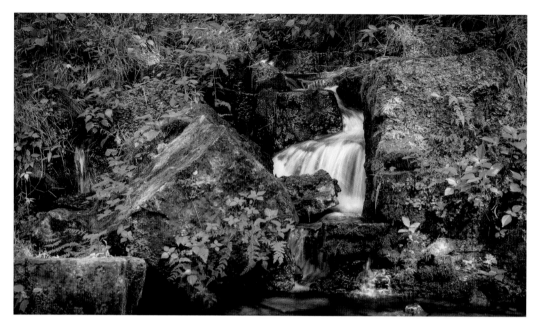

The Apple River features a series of rapids near the end of its route through northwestern Wisconsin. I found this small offshoot cascading along the shoreline.

BIG FALLS ON THE EAU CLAIRE RIVER (WEST ENTRANCE)

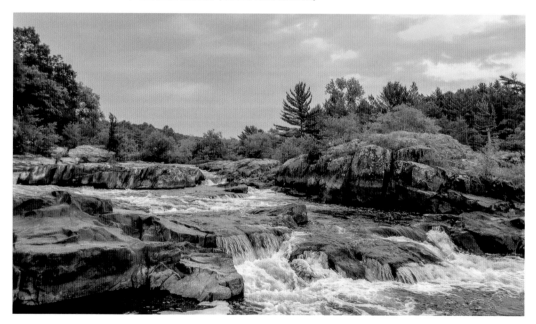

Big Falls on the Eau Claire River in Seymour is east of Eau Claire. There are two different access points, one on each side of the river. Parking along the west side allows for the exploration of fascinating rock formations. When the water is shallow, you can walk across the flat rocks onto an island.

BIG FALLS ON THE EAU CLAIRE RIVER (EAST ENTRANCE)

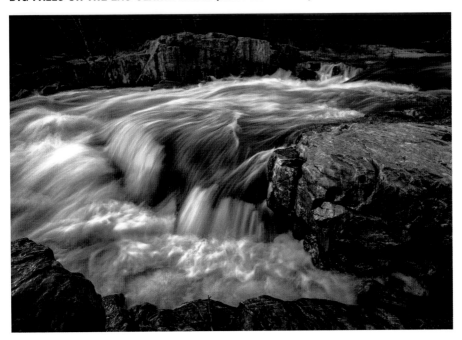

The Eau Claire River splits into two falls, then rejoins around the center island. Parking along the east side gives you this alternate perspective that is equally captivating from a higher elevation. The water levels vary on the Eau Claire River, going from calm to a surging torrent.

BIG FALLS ON THE JUMP RIVER

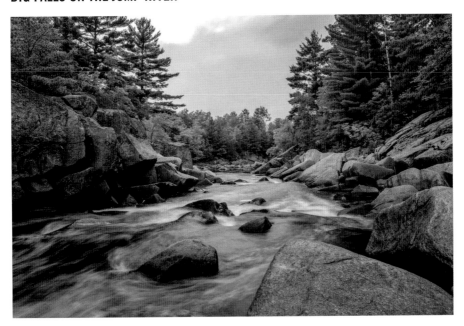

There are also Big Falls on the Jump River in Kennan. Thunderous rapids echo their way up to the parking lot. Glacial drift from the last ice age comprises this shoreline.

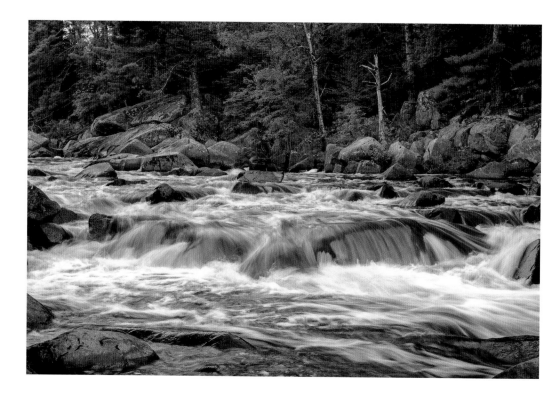

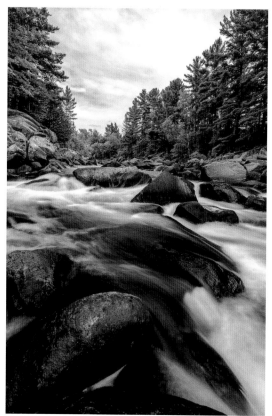

Above: As the sound of roaring water increases, you will reach the prominence where the waters culminate into churning rapids. Some of these rapids manifest furling backflows, where the waves appear to roll backward. This type of movement is known as an eddy.

Left: Massive boulders sporadically protrude along this section of the Jump River. The water levels fluctuate throughout the year, often concealing these boulders beneath the channel.

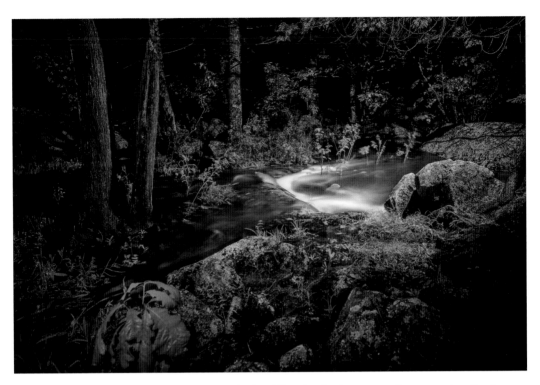

The Jump River overflows and submerses the forest floor, forming temporary watercourses along the shore.

BUTTERMILK FALLS ON BUTTERMILK CREEK

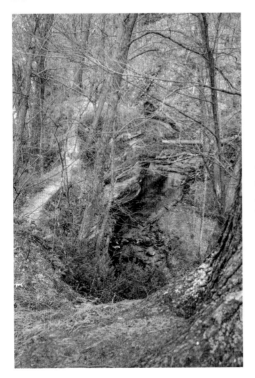

Buttermilk Falls is a lesser-known hidden treasure south of Osceola, accessible by a short hike overlooking a grassy savannah at the Standing Cedars Trailhead. The trail eventually narrows as it juts across a promontory. Sheer drop-offs parallel the pathway slick with fallen pine needles. My exploration concludes along the upper ridge of the trail with a view down into the canyon. Buttermilk Creek curves around a bluff as I hear the water tumbling thirty feet and out of sight. A fallen log serves as a makeshift bridge to reach the other side. Sometimes the risks outweigh my desire to proceed any further for the sake of a closer photograph.

CASCADE FALLS AT WILKE GLEN ON OSCEOLA CREEK

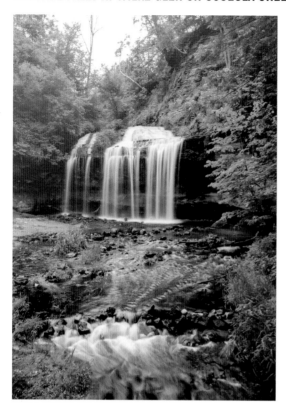

Left: Cascade Falls is a majestic veil of water plunging over a twenty-five-foot overhang into a wooded basin. The water accumulates in a shallow pool as the outflow trickles onward to join the St. Croix River.

Below: The stairway descending into Wilke Glen resembles a maze. Glimpses of the Cascade Falls appear through the treetops and will increase your anticipation to reach this waterfall.

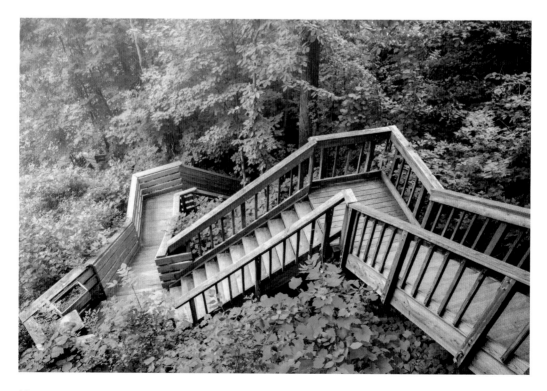

GIGER FALLS AND OSCEOLA CREEK FALLS AT WILKE GLEN

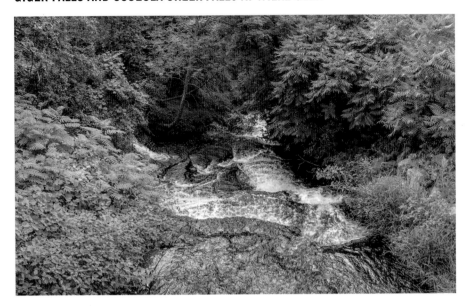

Osceola Creek flows through Wilke Glen and offers a series of waterfalls in downtown Osceola. From the top, Giger Falls emerges to join Osceola Creek Falls before presenting its grand finale as Cascade Falls.

COON FORK CREEK

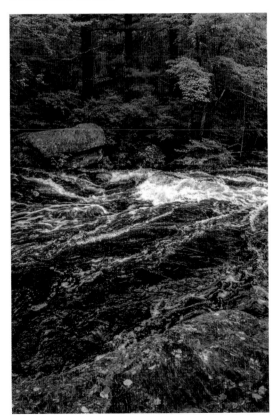

A swirling deluge of rapids appears after heavy rains along Coon Fork Creek near Augusta. Seasonal streams flow from the forest, contributing more water to this powerful current.

COPPER FALLS STATE PARK - COPPER FALLS

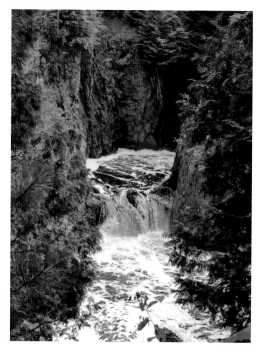

Copper Falls at Copper Falls State Park in Mellen offers an abundance of waterfalls at the confluence of two rivers. Copper Falls is the result where the Bad River and Tyler Forks converge as one. There are miles of hiking trails encompassing both rivers. These two rivers exhibit four waterfalls and many rapids throughout the park. The brownish hue of the water is due to high mineral content and reminiscent of root beer.

COPPER FALLS STATE PARK - BROWNSTONE FALLS

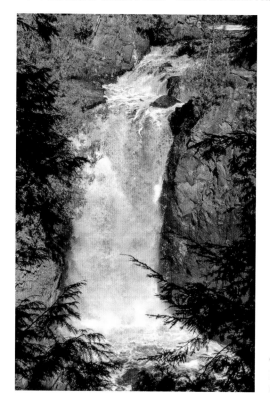

Brownstone Falls into the Bad River at the north end of the park. Catch a glimpse of this final plummet as a branch of Tyler Forks ejects over the rocky cliffs.

COPPER FALLS STATE PARK - TYLER FORKS CASCADE

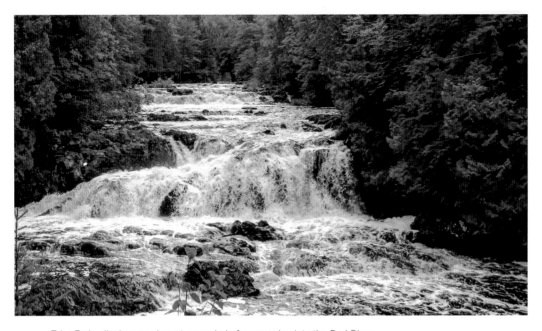

Tyler Forks displays an elegant cascade before merging into the Bad River.

COPPER FALLS STATE PARK - THE BAD RIVER NEAR THE CONFLUENCE

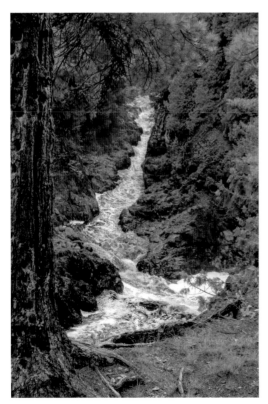

Viewing the Bad River from the opposite side can be very disorienting. It seems to create an illusion, as though the river is flowing away uphill rather than tumbling forward. Observation platforms offer various vantage points of this intricate conflux.

COPPER FALLS STATE PARK - RED GRANITE FALLS

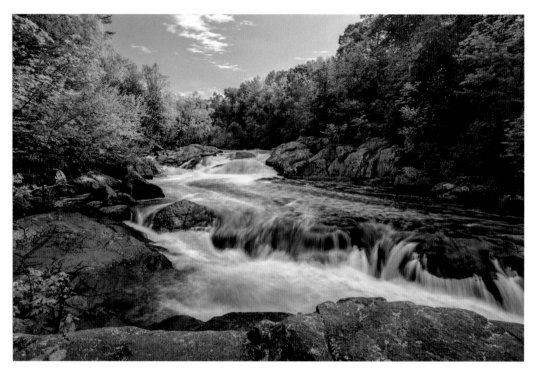

Red Granite Falls on the Bad River rumbles along as it enters the southwestern edge of Copper Falls State Park.

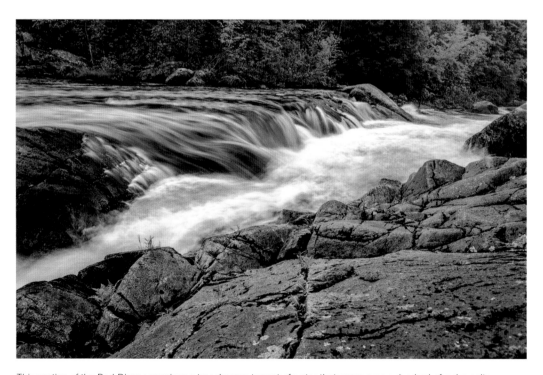

This section of the Bad River comprises a treacherous torrent of water that rages over a riverbed of red granite boulders. The Bad River flows onward to merge with Tyler Forks.

RAPIDS ON THE BAD RIVER

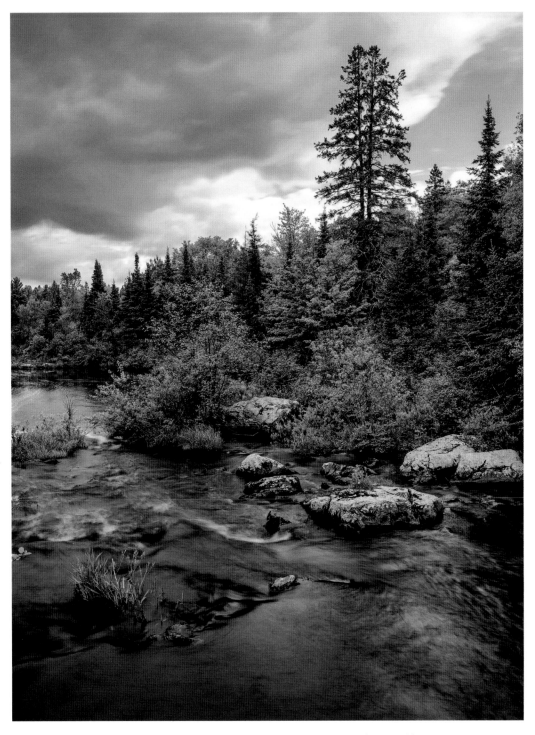

The Bad River reveals some rippling rapids upstream as a storm approaches near Morse.

RAPIDS ON THE BRUNET RIVER

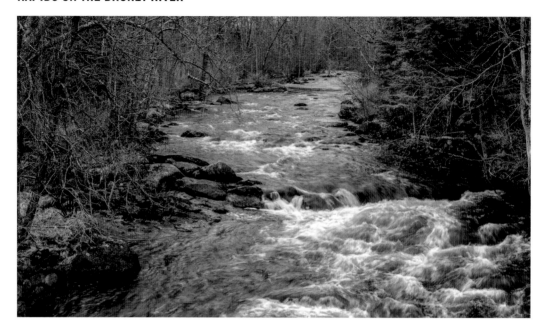

The Brunet River offers a small set of rapids. This scene is viewable from a narrow bridge on Old J near Winter.

DAVE'S FALLS

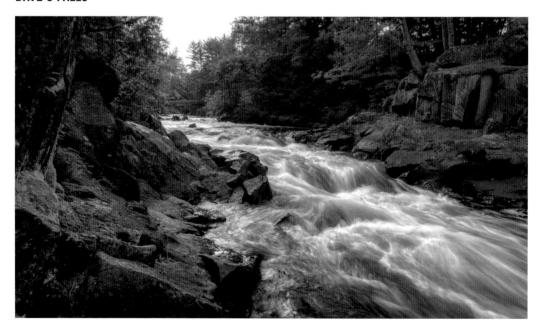

Dave's Falls on the Pike River in Amberg. As with all parks in Marinette County, a parking permit is necessary. If you plan to see more than one waterfall during your visit, day passes are a great option.

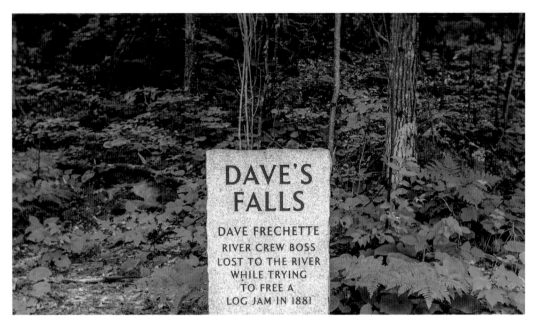

According to history, a Lumberjack named Dave fell into the river while trying to free a log jam. Therefore, the name Dave's Falls was given to this treacherous section of the Pike River.

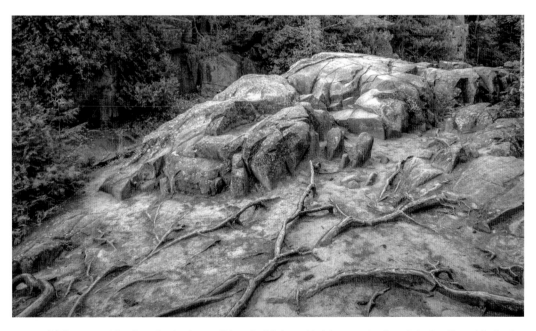

While approaching the edge to observe this waterfall, try not to trip on protruding obstacles. If you blindly step backward while taking a selfie, you might join Dave. There are no railings, so watch your step as you explore at your own risk.

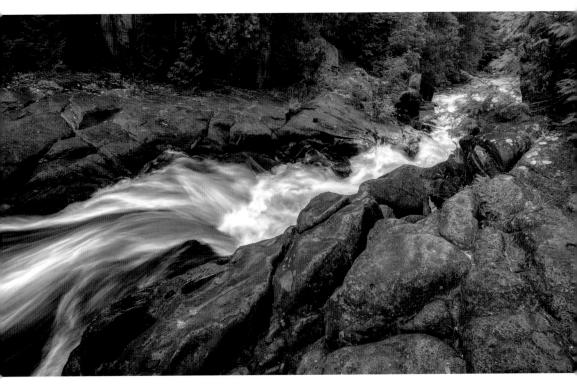

Here is where that fateful log jam occurred. The Pike River extrudes through a narrow chasm, as seen from over the edge.

DELLS OF THE EAU CLAIRE RIVER

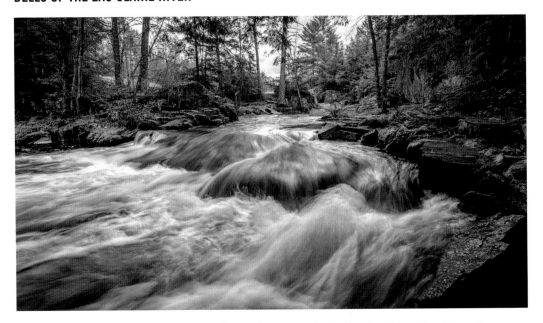

Dells of the Eau Claire River is near Hogarty. An impressive outcrop of rocks lines the shores along this portion of the river.

DEVIL'S PUNCHBOWL

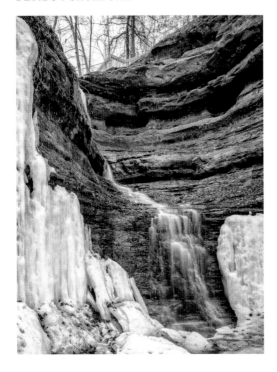

Devil's Punchbowl in Menomonie has free parking available. A long staircase leads down into the hollow. Be sure to use the railings as the steps are often slippery. This water flow is best to view after heavy rains or during the springtime.

DEVILS RIVER

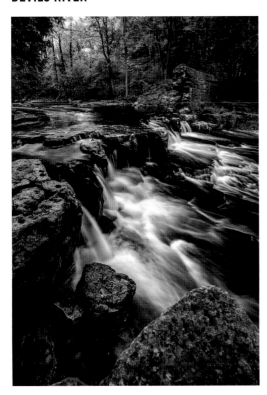

Devils River Falls in Maribel is on private land and accessible through a paid campground with a watermill on-site. "The Old Rock Mill" is on the National Register of Historic Places. For the lovers of waterfalls, the main spectacle lies just behind the campsites.

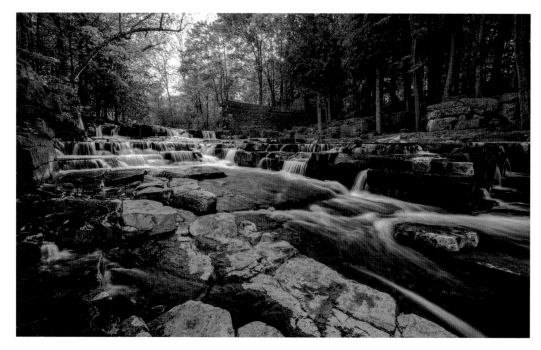

This mesmerizing display is a multi-step waterfall over a series of flat rocks. I spent a while here, entranced by its pure elegance.

DUNCAN CREEK

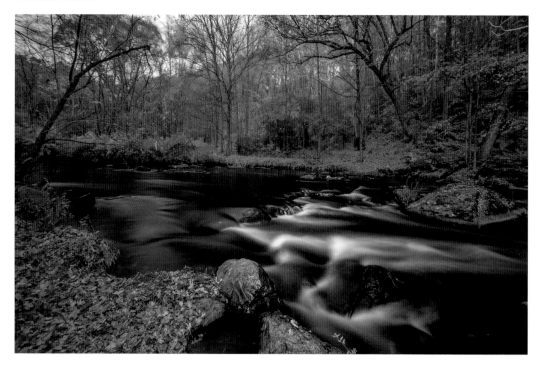

A small series of rapids appear along Duncan Creek at Irvine Park in Chippewa Falls. There is also an unnamed ephemeral waterfall that trickles down a gorge behind the duck pond.

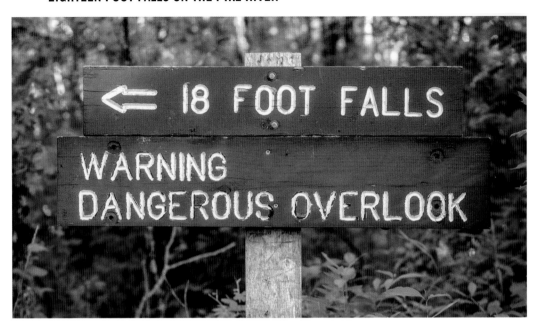

Above: Eighteen Foot Falls in Dunbar is down a rugged trail that weaves over rocky hills and under fallen trees.

Right: Upon reaching the falls, the views are limited. Please be cautious while trying to catch a better perspective.

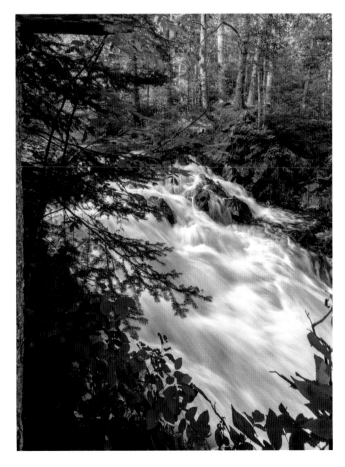

THE FLAMBEAU RIVER

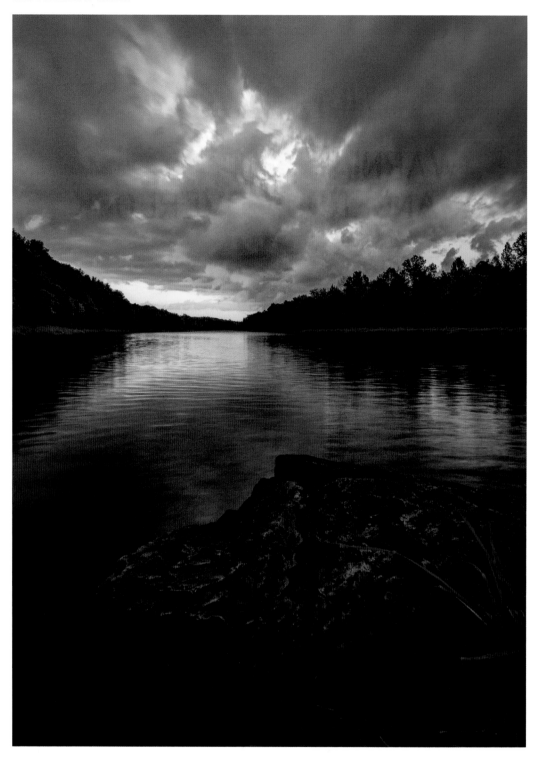

The Flambeau River is deceptively calm when the water levels are high. The faint rumble of Beaver Rapids emanates from the horizon here at Beaver Landing.

FONFEREK'S GLEN

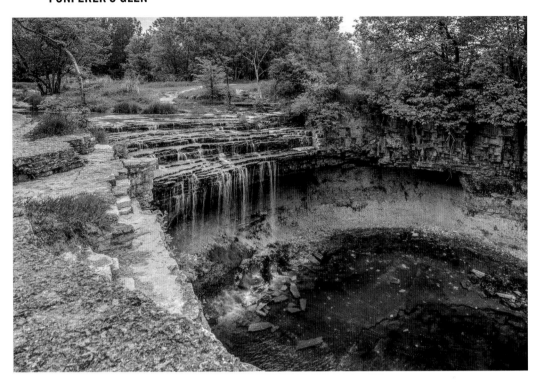

Fonferek's Glen is within the vicinity of Green Bay. There is a donation box in the parking lot to help maintain the grounds. The veil of falling water is thin unless after rainfall.

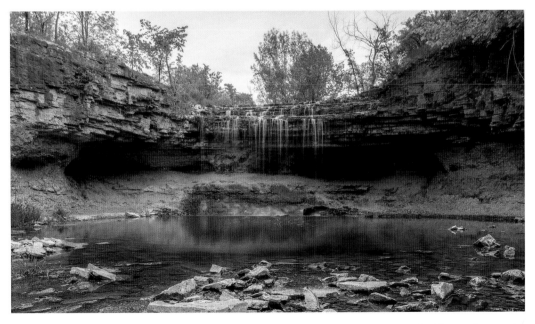

After a precarious descent into the hollow, I found where many fish dove to their deaths. The smell was awful, and the mosquitoes were relentless.

FOSTER FALLS ON THE POTATO RIVER

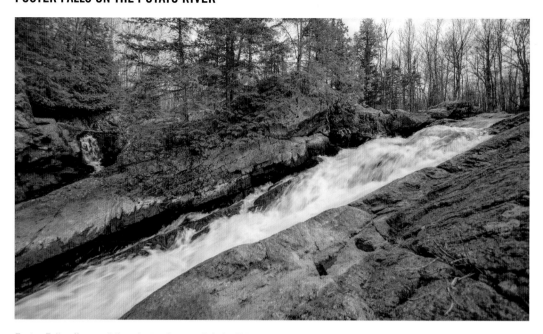

Foster Falls offers a sliding chute of water. A fork offshoot produces an adjacent waterfall. Many thrill-seekers favor this portion of the Potato River.

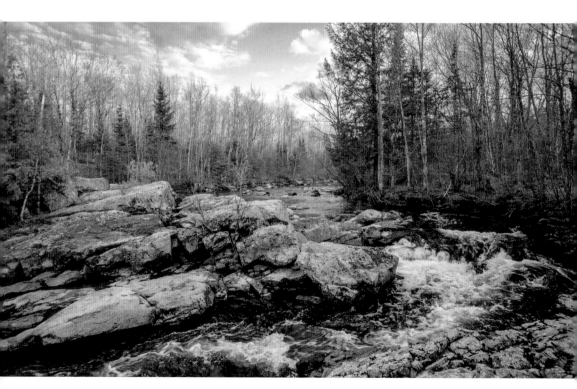

The topside of Foster Falls is a waterfall all of its own. The Potato River presents many falls throughout Ashland and Iron counties.

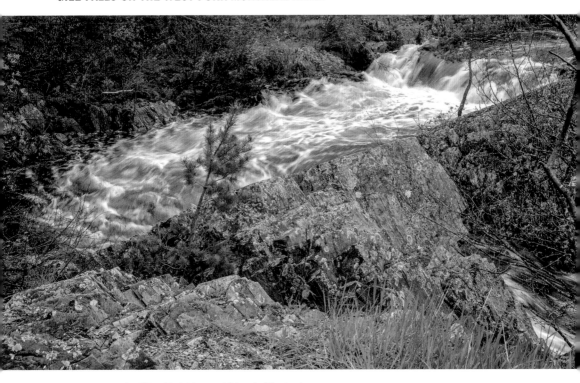

Gile Falls is on the West Fork Montreal River in Montreal.

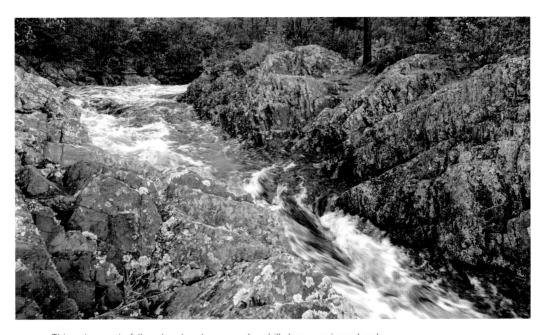

This unique waterfall angles sharply upon a downhill slope over jagged rocks.

WEST FORK MONTREAL RIVER

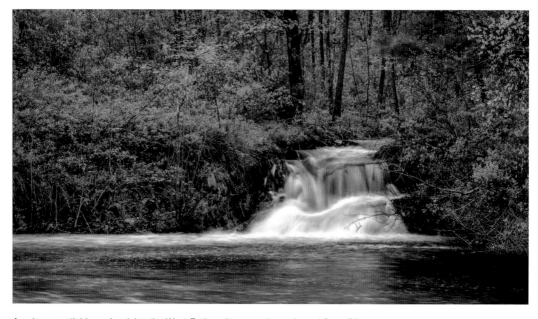

A subsequential branch rejoins the West Fork as it proceeds northward from Gile.

GLEN PARK - RIVER FALLS ON THE SOUTH FORK KINNICKINNIC RIVER

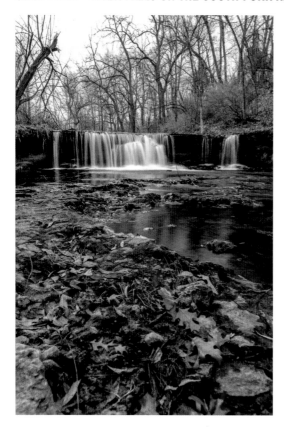

Glen Park offers a series of waterfalls on the South Fork Kinnickinnic River. There is a suspension footbridge to view the falls below. This remarkably sprawling city park features one of the most picturesque waterfalls in the state. Here you will discover three different waterfalls, the first being this upper tier. It resembles a sheet of water freefalling into the ravine and is best known as River Falls.

GLEN PARK - SOUTH FORK KINNICKINNIC RIVER

The middle falls on the South Fork can be difficult to view from the topside. There are steep pathways with no visible way down. This area is not fenced-in and is conceivably unsafe for those who desire a closer view. Wading upstream might be a safer option if the water is low.

GLEN PARK - WATERFALL AT LAKE GEORGE DAM

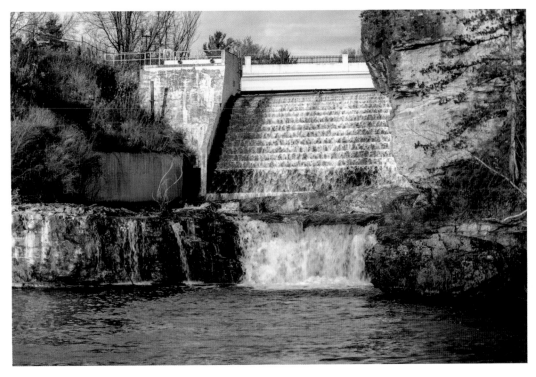

Following the downhill trail leads to the riverbed. From here, the third waterfall is visible at the base of Lake George Dam.

HAMILTON FALLS ON THE NORTH FORK EAU CLAIRE RIVER

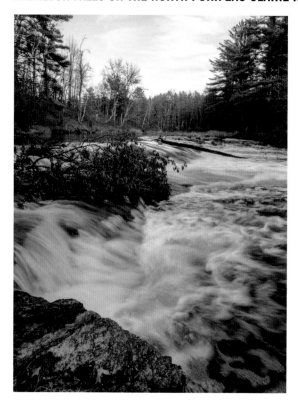

Hamilton Falls presents a short ledge on a river bend in Wilson Township, northeast of Augusta.

HORSESHOE FALLS

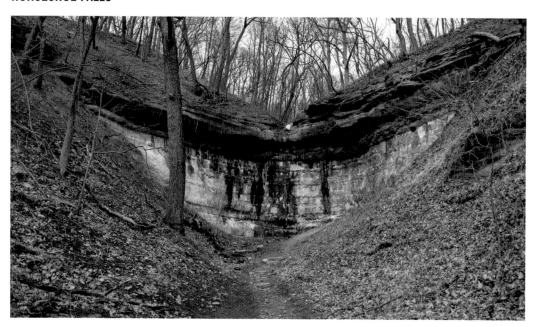

Horseshoe Falls at Perrot State Park in Trempealeau features seasonal runoff from Brady's Bluff into a hollow. It was disappointing to discover only tiny drops of water. I think this waterfall should be named "Drip Falls."

HOUGHTON FALLS AND ECHO DELLS

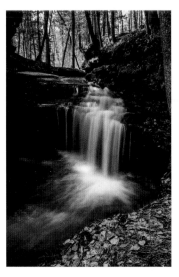 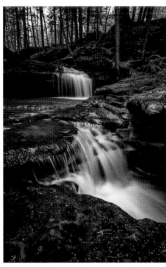 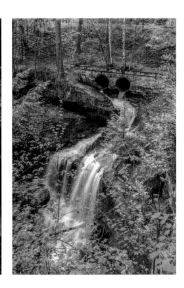

Above left: Houghton Falls and Echo Dells has free parking with a donation box in Washburn. This unique State Natural Area offers a series of falls along a quiet shore of Lake Superior. Typically, this is a dry canyon for most of the year. The hike begins on a winding path and soon fills with echoes of splashing water resonating in the distance.

Above middle: The upper tier offers a six-foot plunge into a shallow pool that flushes through a series of downturns. Once you reach the canyon, watch your step. Many tangled roots protrude along the footpath.

Above right: The waters culminate and empty through culverts resulting in a final sixty-foot dive into Lake Superior. Dense foliage obstructs the views along these sheer cliffs.

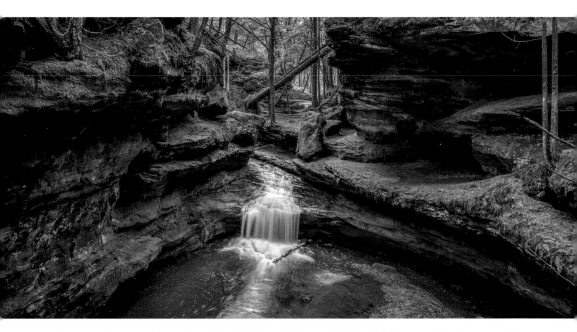

An unnamed stream extends through Echo Dells and dives another twenty feet or more into the canyon. These rock formations are the result of many years of erosion.

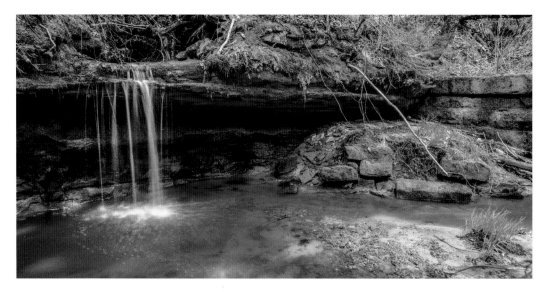

Further down the trail, a separate stream reveals a small waterfall. Please be respectful of this fragile and delicate environment.

LAKE SUPERIOR AT HOUGHTON FALLS

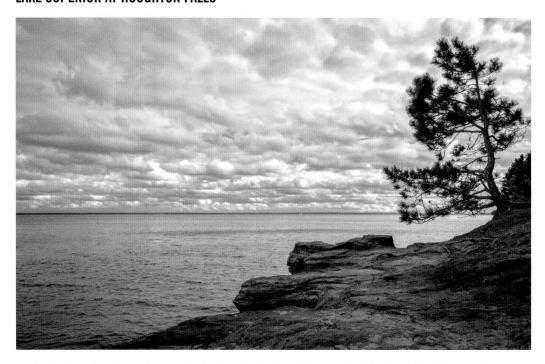

Continuing along the pathway, the sounds of falling water begin to disperse. You will arrive at the bluffs along the shore of Lake Superior. This place is one of my favorites. I could sit here for hours along this National Lakeshore Preserve while listening to the waves crashing beneath the overhang. It is usually a quiet place and far off the beaten path. There is no rock climbing or swimming allowed here.

LAKE OF THE FALLS

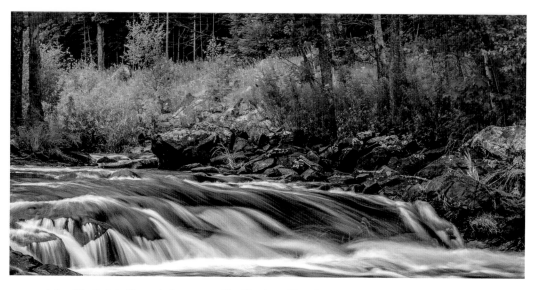

Lake of the Falls in Mercer is the source of the Flambeau River. The outflow from the lake splits into two cascading sections before converging as the Flambeau.

LITTLE LACROSSE RIVER

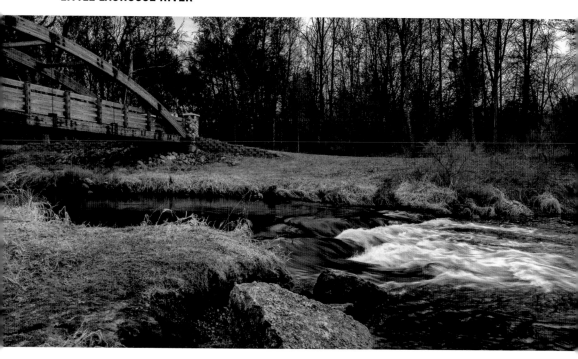

The Little Lacrosse River flows through Amundson Park in Sparta. A small set of rapids form upon exiting beneath a footbridge.

LITTLE FALLS ON THE SOUTH FORK FLAMBEAU RIVER

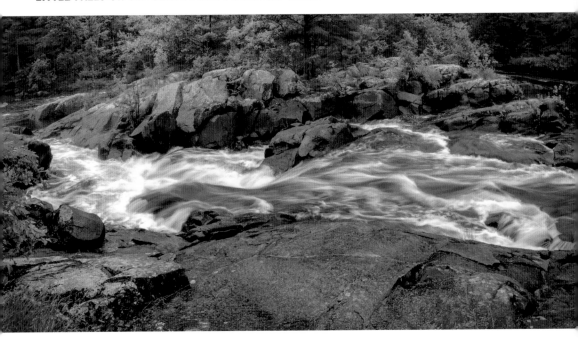

Little Falls is technically much closer to Hawkins than Winter. The primary access is from a small parking lot on County Road M in the Flambeau Hardwood Forest. Many people enjoy canoeing, kayaking, and rafting along this section. The pathway to the falls is well maintained down a long and gradual grade through this state forest.

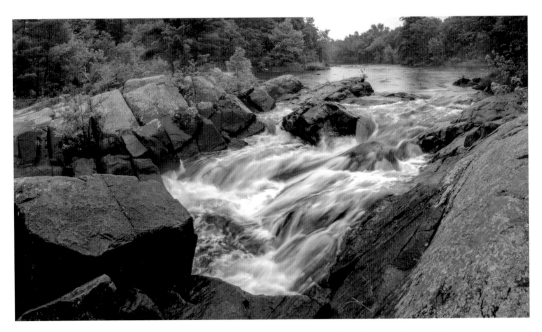

Little Falls is more like rapids than a waterfall. The water levels fluctuate depending on the rainfall and dams downstream.

LOST CREEK FALLS ON LOST CREEK

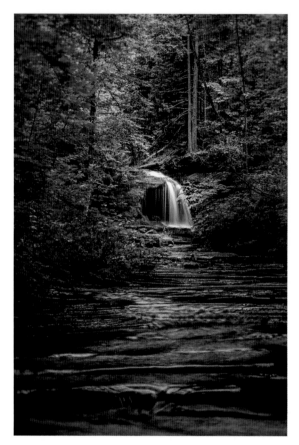

Left: Lost Creek Falls in Cornucopia. Reaching this waterfall is quite a long hike through the northern woodlands. The trails through the forest consist of dirt paths and well-constructed boardwalks.

Below: After a lengthy walk and much anticipation, you will finally arrive at the centerpiece of this enchanting forest. This tranquil waterfall is one of the most remote in all of Wisconsin. Unfortunately, some visitors left behind cairns. I refer to this balancing act as "Controversial Art Involving Rearrangement of Nature." These nuisances arose like rigid spikes littering the entire length of the stream.

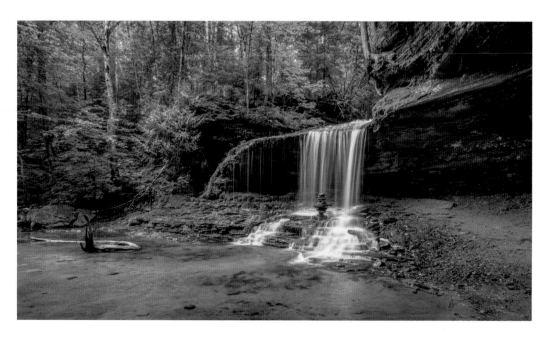

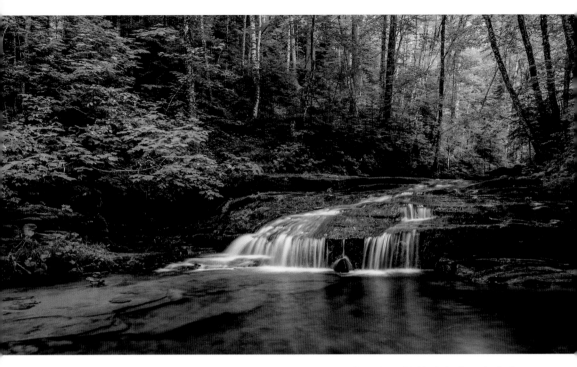

Some shorter cascades exist further downstream. Like all rivers north of the Great Divide, Lake Superior is the watershed.

LOST FALLS ON ROARING CREEK

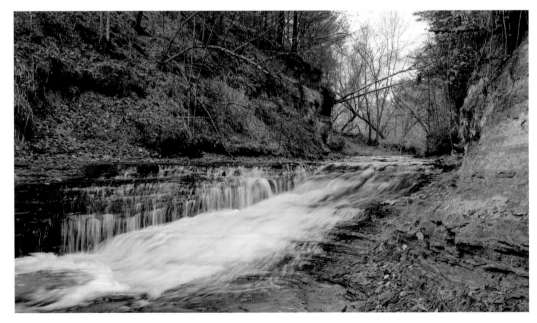

Lost Falls on Roaring Creek in Irving is on campground property with roadside parking. A trail leads down from the road into a brushy and sandy terrain. Be cautious of the quicksand near the shoreline. Two waterfalls exist here: Lost Creek Falls and a less impressive Roaring Creek Falls further downstream.

MAYS LEDGES ON THE BOIS BRULE RIVER

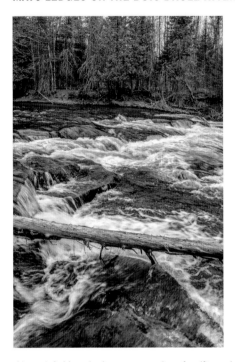

Above left: Mays Ledges are a series of swift-moving rapids that fall over ledges of red shale bedrock on the Bois Brule River (pronounced *bwah brool*). Many people refer to this river simply as the Brule.

Above right: Alongside the stairway leading down to Mays Ledges, water flows through a narrow trench of shale rock. At first glance, I assumed this trench was nothing more than runoff with an accumulation of mud puddles. Upon further inspection, this spring-fed source originates from the forest above.

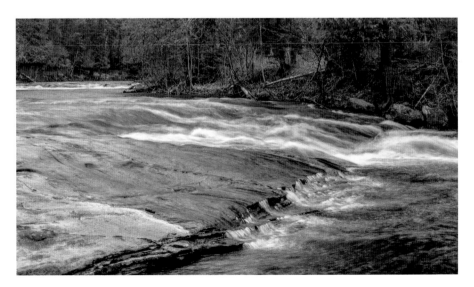

There are three notable drops in the elevation at Mays Ledges. The last leg of the Brule descends over 300 feet during its last nineteen miles as it proceeds northward to Lake Superior. This river offers an abundance of adventure for anglers and paddlers.

THE MONTREAL RIVER

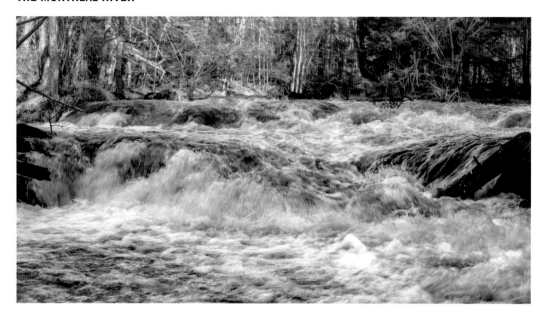

The Montreal River is the natural border between Wisconsin and Upper Michigan. This hurtling surge of water breached the banks during my visit to Hurley. There are many rapids and waterfalls along its course. This photo is near Interstate Falls. I could not discern the precise location of the waterfall due to the high water.

MORGAN FALLS

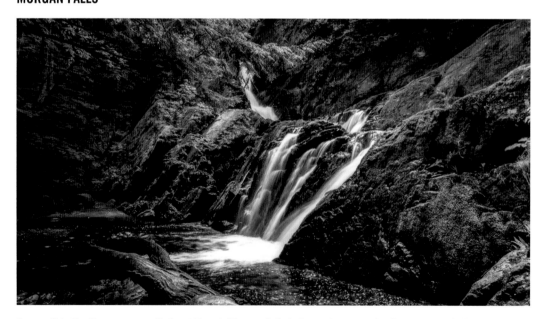

Deep within the Chequamegon National Forest, Morgan Falls is the main spectacle of an unnamed tributary flowing into Morgan Creek. This waterfall is purportedly the second highest in the state at seventy feet, with some claiming it is as tall as 100. Upon seeing the falls in person, it doesn't appear much higher than thirty feet. This thin and exotic cascade descends a slope of red iron-bearing rock. The stream angles sharply at the base and fans into a glorious display.

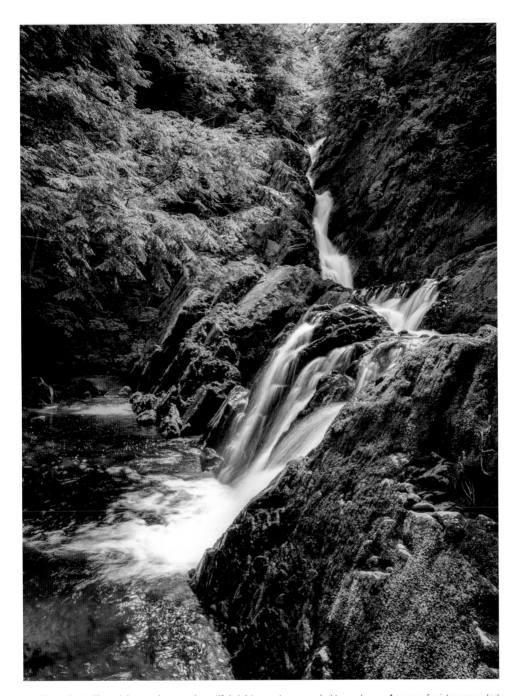

Upon the trail's end, I peered upon a beautiful sight as water cascaded towards me. A spray of mist surrounded me as a downdraft of cool breeze brushed upon my face. Overcome with joy from the magical scenery, it was at this moment I felt an abundance of energy. Negatively charged ions are a good thing—perhaps the reason I seek so many waterfalls. I felt this powerful energy cleanse me. As I looked down to my forearm, my hair was standing on end. I looked all around as I stood alone in the forest. I absorbed as much as I could in what seemed like a timeless vortex. Somehow, the photos failed to capture the essence of this rejuvenating experience. If the fountain of youth exists, its secrets may lie here in the Chequamegon National Forest.

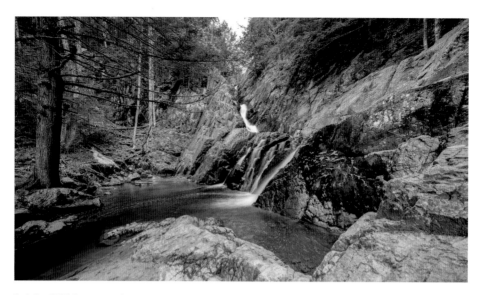

In July of 2016, a severe thunderstorm tore through the forest, leaving several trees uprooted throughout the trails. Access was closed to the public. The park remained closed for three years after the storm. After a few years of clearing away debris and reconstructing the boardwalks, the park reopened in the spring of 2019.

MORGAN FALLS TO ST. PETER'S DOME

OJIBWA PARK

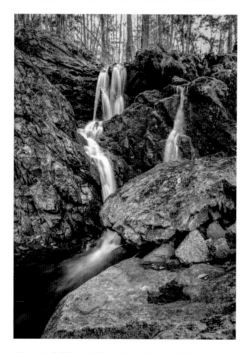

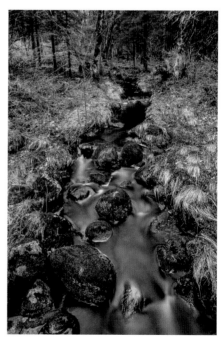

Above left: The uphill path leading to St Peter's Dome is a strenuous hike. There is a waterfall along the way within a rocky glen.

Above right: Ojibwa Park features a small stream flowing from the woods. This unnamed streamlet drains into the Flambeau River in Ojibwa.

PATTISON STATE PARK - RAPIDS ON THE BLACK RIVER

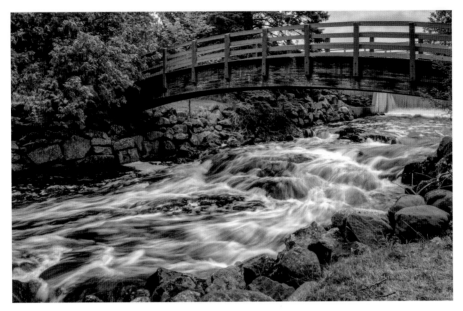

Pattison State Park in Superior features two main attractions. The outflow from Interfalls Lake continues through rapids underneath a footbridge. The river flows a short distance reaching the edge of land.

PATTISON STATE PARK - BIG MANITOU FALLS ON THE BLACK RIVER

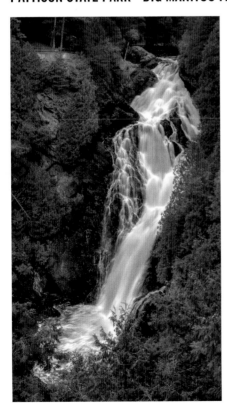

Big Manitou Falls on the Black River is the king of them all. The Black River transforms into a cataract, plummeting 165 feet over the precipice into the abysmal gorge below. This waterfall is the only one of its kind in the Badger State.

PATTISON STATE PARK - LITTLE MANITOU FALLS ON THE BLACK RIVER

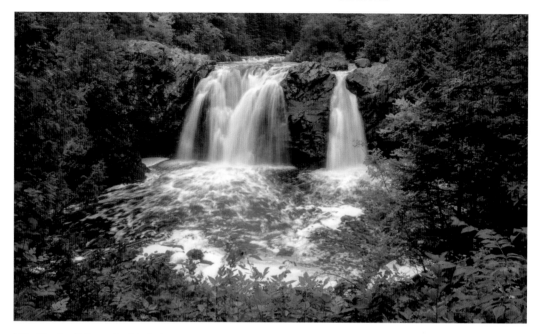

Little Manitou Falls on the Black River is a short drive to the south end of the park. The size of this waterfall is modest in comparison to Big Manitou.

MARCH RAPIDS ON THE BIG EAU PLEINE RIVER

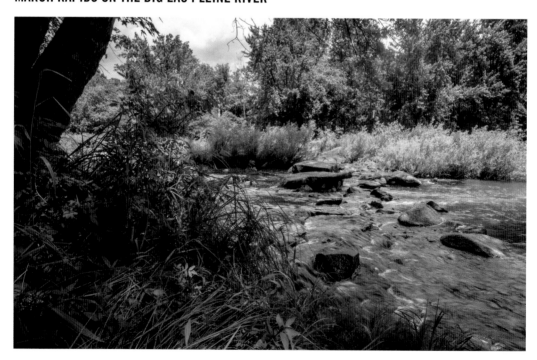

March Rapids consists of a shallow stream with flat rocks interspersing the waterway. Perhaps at one time, it was more impressive before the construction of a dam downstream in Medford.

PERRY CREEK FALLS ON PERRY CREEK

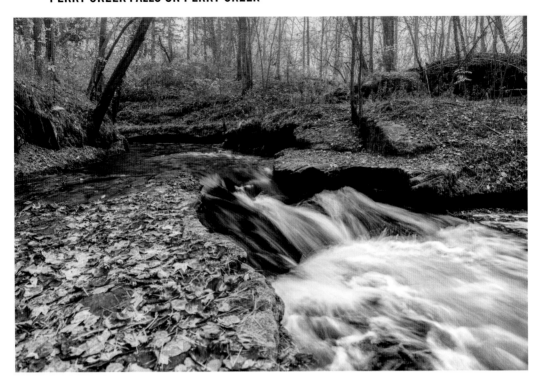

Perry Creek Falls is on a tributary of the Black River. It flows through the Black River State Forest in Brockway. It is readily accessible from the parking lot. Follow the trail into the woods and cross the suspension footbridge to discover all that awaits.

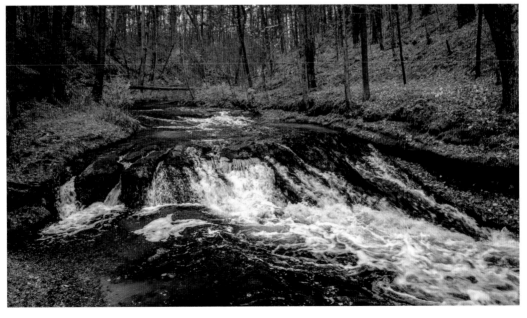

The main attraction is hidden around the bend. Here you will encounter a small canyon where the creek carves through walls of sandstone.

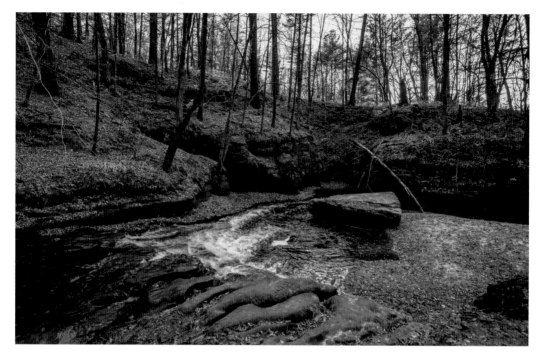

The path follows the creek upstream and crosses another footbridge. The trail circles the upper ridge back to the parking lot.

PIPESTONE FALLS ON PIPESTONE CREEK

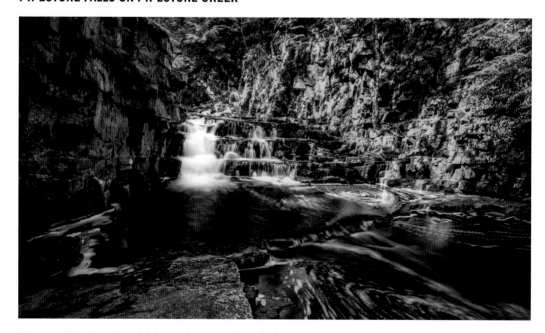

Pipestone Falls flows through tribal land near Radisson. This waterfall is unmarked and is confusing to locate along a forest road where each tree looks the same.

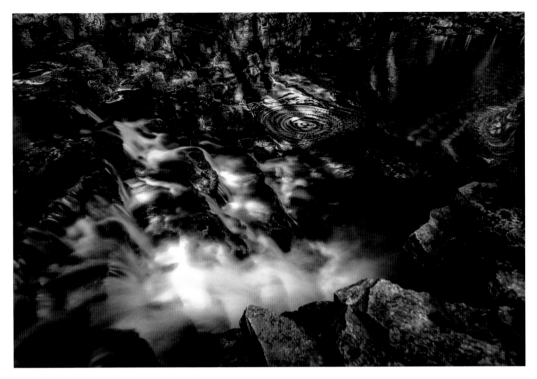

Pipestone Creek presents a multi-step watercourse that flows deep through the forest. Beware the mosquitoes!

Permission to access this location from the Lac Courte Oreilles tribal council is not required but is a mindful gesture. A friend of mine obtained permission for our brief visit.

POTATO RIVER FALLS (UPPER)

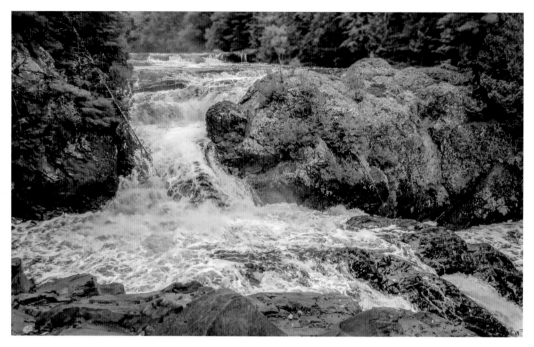

Potato River Falls in Gurney has upper and lower falls. Prepare for an exhausting climb to view either segment.

POTATO RIVER FALLS (LOWER)

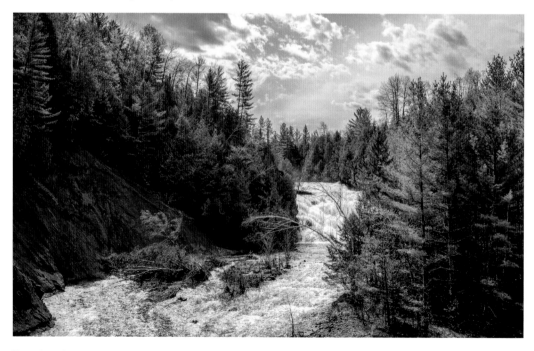

Down in a deep ravine, it was a balmy eighty degrees. For every step downward, each would seemingly double during my ascent.

POTATO RIVER FALLS (LOWER-LEVEL STAIRCASE)

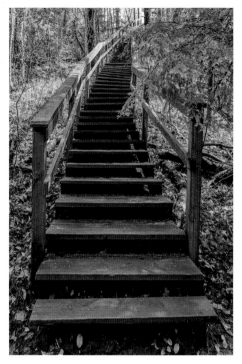

There are a series of trails that join several sets of wooden staircases. I lost count of how many steps during my return climb.

THE RED CEDAR STATE TRAIL

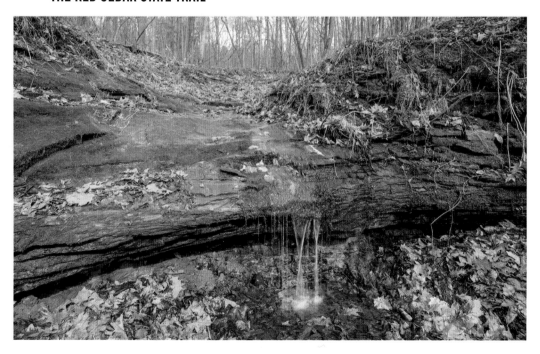

The Red Cedar State Trail near Dunnville features a few rivulets beside the walkway. The first is about a mile north of the boat landing, cascading in a shallow trench.

THE RED CEDAR STATE TRAIL - "RED CEDAR FALLS"

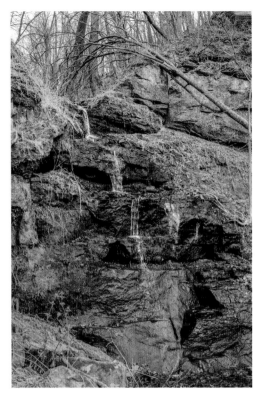

Red Cedar Falls into the Red Cedar River a mile and a half into the hike. This trickling runoff is only reachable by bike or foot along the Red Cedar State Trail.

RIB FALLS ON THE RIB RIVER

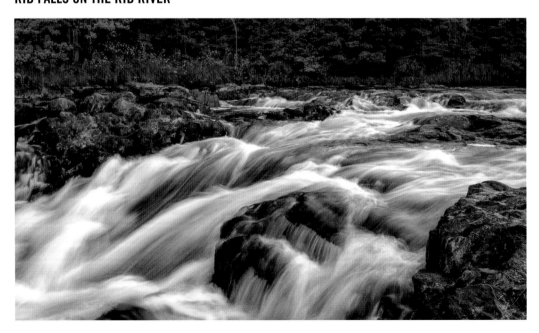

Rib Falls is where the Rib River manifests into a high-velocity current. When the water levels are low, falls become more prevalent.

ROUSE FALLS ON ROUSE CREEK

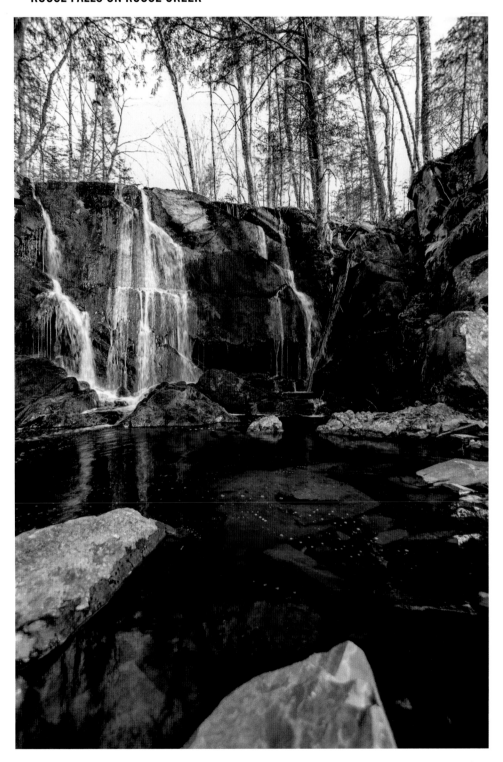

Rouse Falls is a lesser-known block-type waterfall that rouses the senses. This sequestered stream is defying to reach yet offers one of the prettiest waterfalls in all of Iron County.

SILVERBROOK FALLS AT INTERSTATE STATE PARK

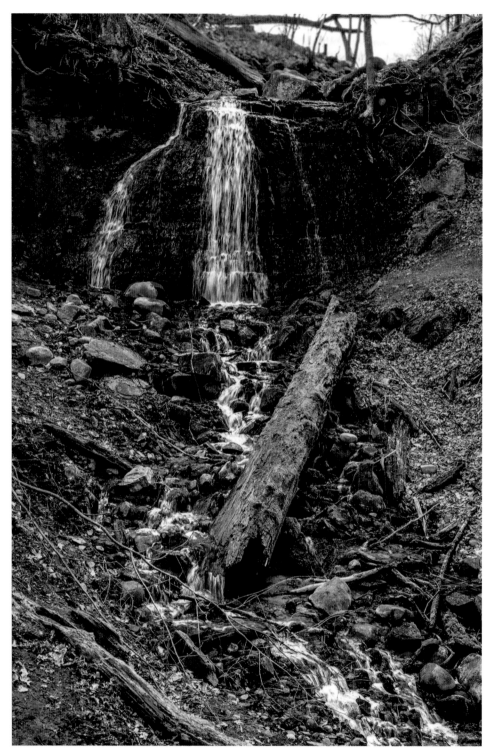

Silverbrook Falls showcases a majestic scene as it tumbles into a deep ravine. This waterfall is along the southern edge of Interstate State Park, only a short descent down the Copper Mine Trail.

SISKIWIT FALLS ON THE SISKIWIT RIVER (UPPER)

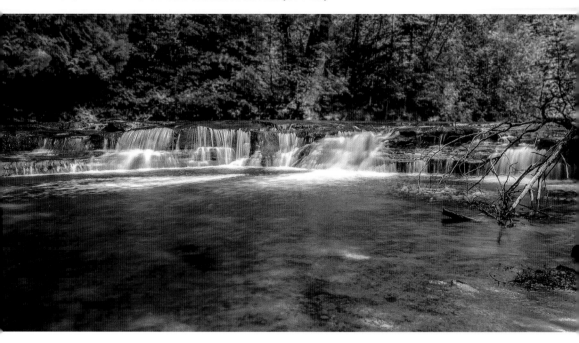

Siskiwit Falls has limited parking on the roadside of Cornucopia. This shallow river features a series of cascades, with the upper part visible from the bridge.

SISKIWIT FALLS ON THE SISKIWIT RIVER (LOWER)

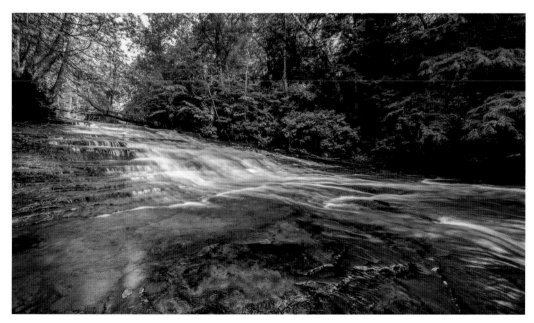

The last part of the falls is a fast-moving slope of water that continues onward to meet with Lake Superior. The trail alongside the river follows the gradual slope downhill. The water is shallow but deceivingly dangerous as it moves swiftly over the slick riverbed.

SPRING CAMP FALLS ON THE WEST FORK MONTREAL RIVER

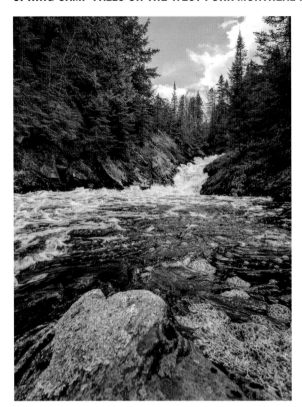

Left: The forest road leading to Spring Camp falls is most suitable for off-road vehicles. It soon becomes impassable with muddy ruts. Upon cresting the last hill, you will hear the water rumbling in the distance.

Below: A closer view shows a hurtling surge of water channeling through a narrow chasm as it enters the gorge. This particular waterfall is not the easiest to find, nor is the road simple to navigate. Consider driving as far as you can, then park to hike the rest of the way.

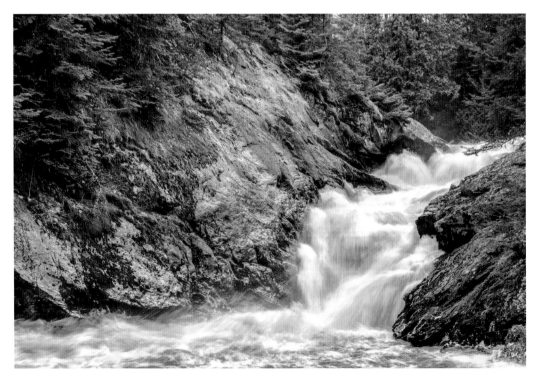

SPRING CAVE FALLS

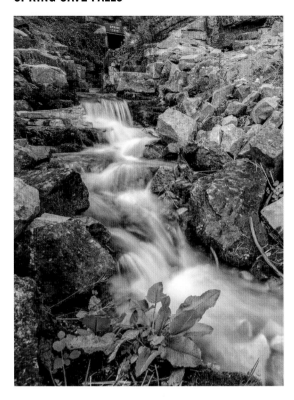

Spring Cave Falls is a spring-fed aquifer flowing from a cavern in Maribel. This clear spring water tumbles over white limestone on its way to the West Twin River.

SPIRIT FALLS ON THE SPIRIT RIVER

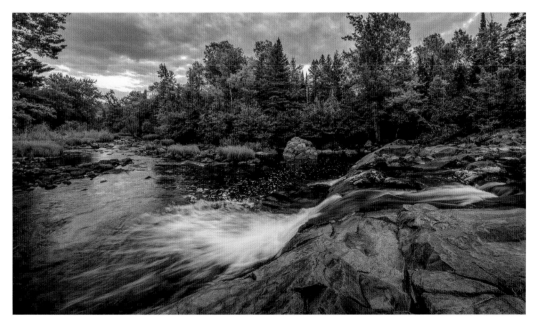

Spirit Falls is in the unincorporated community of Spirit Falls. This scenic waterway is accessible from a dead-end gravel road. It flows through a series of rapids alongside a town with only one tavern.

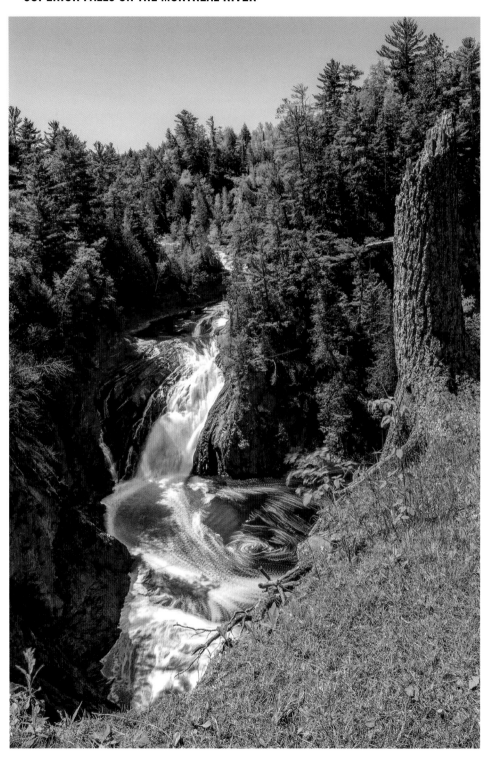

The Montreal River is the natural border between Michigan and Wisconsin. Superior Falls is the easiest to observe from the Michigan side. Fences surrounding the perimeter of the gorge deters closer access.

TRIPP FALLS AT TRIPP FALLS RAVINE

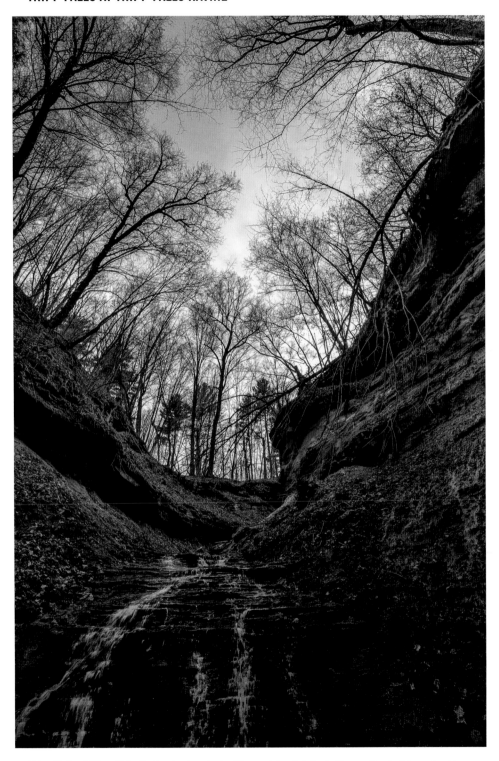

Tripp Falls at Tripp Falls Ravine is abundant with a variety of delicate flora native to this region. Traverse the trail upstream to find this unique peculiarity.

TROUT FALLS ON THE LA CROSSE RIVER

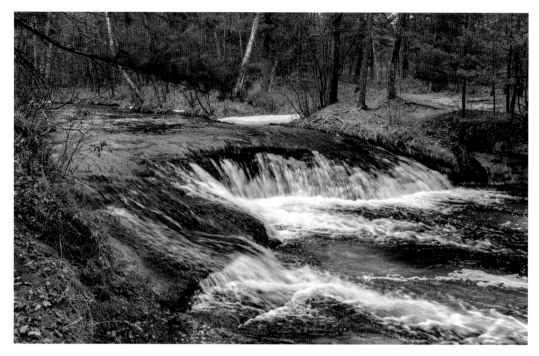

Trout Falls is a waterfall near Fort McCoy. This waterfall is similar in appearance to Lost Falls and Perry Creek Falls. Both are not far north from here. The honey color sand lining the creek bed is likely quicksand. It is a good indication of why there are signs that prohibit entering the water here.

TWELVE FOOT FALLS ON THE PIKE RIVER

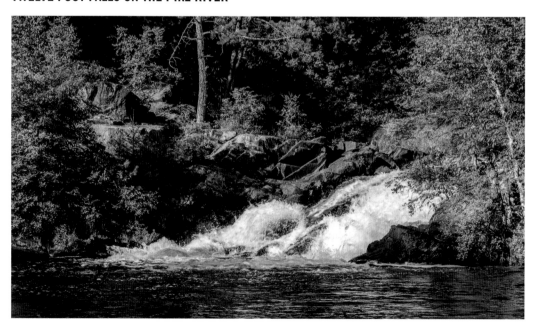

Twelve Foot Falls is a short walk from the parking lot and viewable across a small inlet in Dunbar.

TWIN FALLS ON LARSON CREEK

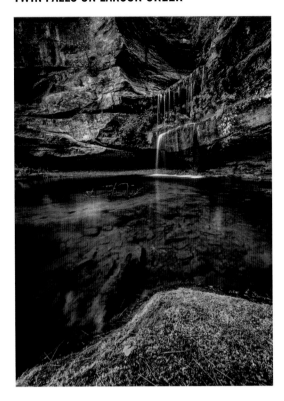

Twin Falls in Port Wing. Down in a deep ravine is a moss-covered world not often seen. A cascading stream spills over the walls in this hidden gorge known as Twin Falls. Its trickling echoes reverberate. Sit here to meditate.

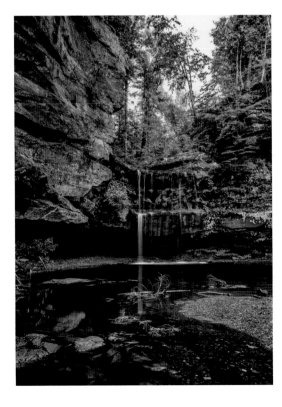

Parking is free in a small lot. There is an overlook at the top of the hill. Accessing the stairway down into the gorge is not permitted.

UPPER TWIN FALLS ON LARSON CREEK

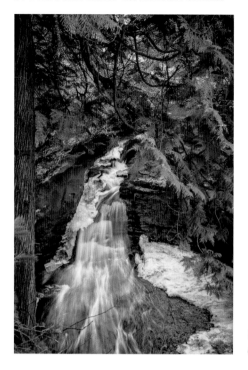

Here is a view of Upper Twin Falls from the observation deck.

TYLER FORKS DELLS ON THE TYLER FORKS RIVER

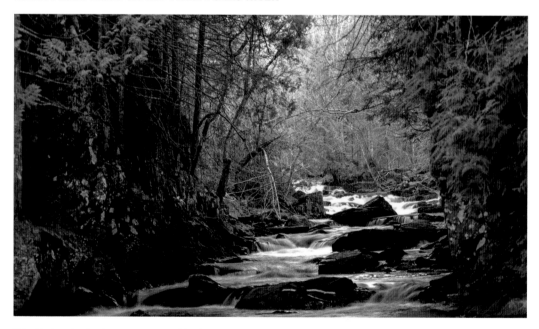

Tyler Forks extrudes from a narrow corridor in the heart of the Penokee Range. These monolithic dells comprise taconite and compress the river into a swift-moving passage. Attempts to mine this region for its high iron content remain on the table. Conservation efforts have proven effective for the time being. This waterway and geological features could face irreparable damages if ever mined for resources.

UPSON FALLS ON THE POTATO RIVER

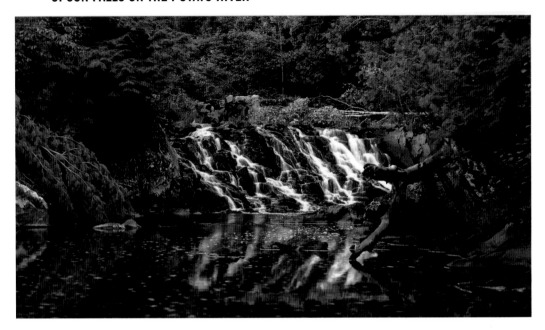

Upson Falls on the Potato River exhibits an elegant display at a small park in Upson. Follow the pathways up the hill to see the complete view of the cascades. This waterfall is one of my favorites. I often stop here on my way to Lake Superior or Michigan.

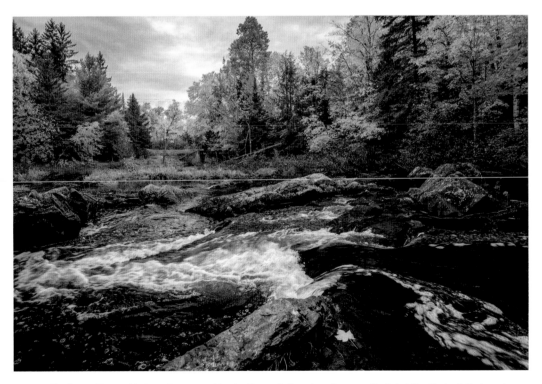

The Potato River swirls through some rapids after Upson Falls and continues northerly to fall as Foster Falls downstream.

WILLOW FALLS STATE PARK - WILLOW FALLS ON THE WILLOW RIVER

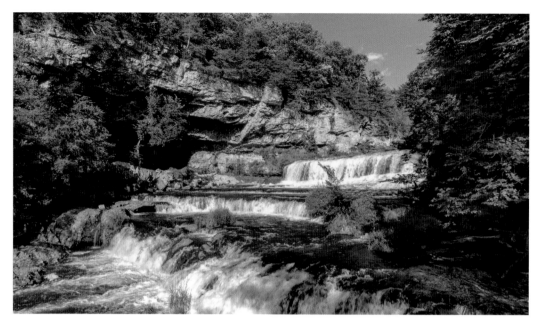

Willow Falls State Park in Hudson is where you will find one of the most impressive waterfalls in the entire Midwest. The paved trails are well maintained but are rather steep. It can be a strenuous hike, especially during your uphill return. As with all state parks, a parking permit is necessary during your visit.

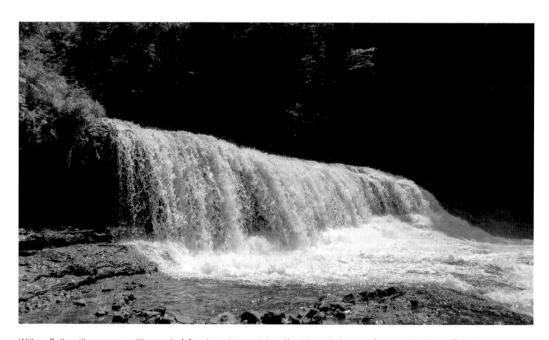

Willow Falls will wow you with wonder! A colossal torrent hurdles through layers of cascading tiers. This place takes the crown for must-see waterfalls. Shown here is the upper plunge. Swimming is allowed. You can even stand behind the falls!

WEBER LAKE (OUTFLOW)

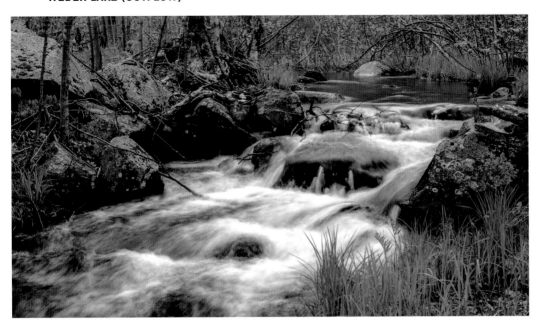

Weber Lake presents an outflow near Upson. I was delighted to find this flowing stream along the roadside.

WREN FALLS ON THE TYLER FORKS RIVER

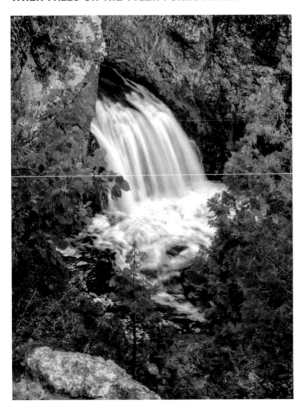

The journey to Wren Falls is accessible through several miles of rugged road.

YARNELL CREEK FALLS ON YARNELL CREEK

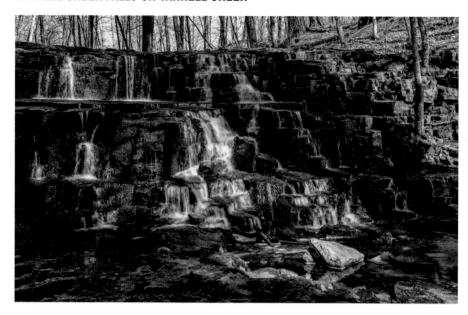

Yarnell Creek Falls is a short way down the Tuscobia State Trail from county road Y near Birchwood. After hiking a mile or so, the path veers into the woods and follows the stream to the waterfall.

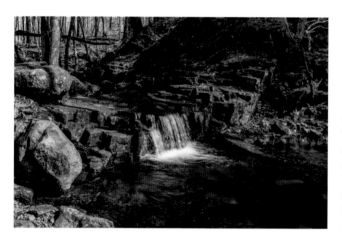

Further downstream, Yarnell Creek plunges a few more feet into a deeper pool of water. This creek is similar in appearance to Pipestone Falls and Signe Falls from neighboring counties.

During the winter months, water trickles beneath the snow as Yarnell Creek continues through the drumlins.

2

CREEKS OF RUSK

Y ou might be from Wisconsin if you call a creek a "crick." Many creeks flow throughout the forests and farmlands in my home county of Rusk. Not many waterfalls exist in Rusk County. I did not know of any until I began to dig deeper. Many of the streams in this northwestern region are shallow and featureless. Some exhibit insignificant rapids, while others present a more significant drop in elevation. Here, I will showcase the ones that offer inspirational views from within their woodland settings.

BECKY CREEK

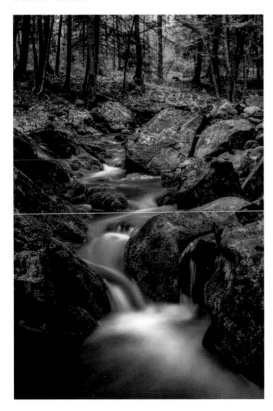

Becky Creek flows from a rocky hillside in the Blue Hills. Most of its route winds through private farmlands on a gradual descent towards the Chippewa River.

BIG WEIRGOR CREEK

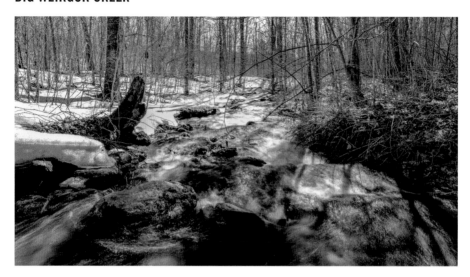

Big Weirgor Creek is a wild and remote stream along the northwestern edge of the county. Try not to encounter the Blue Hills Beast on your journey. Legends say Bigfoot prowls these woodlands.

DEVIL'S KETTLE ON ROCK CREEK

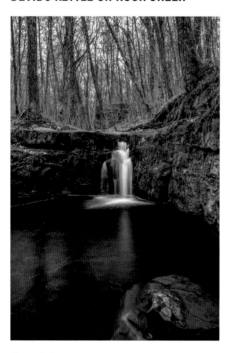 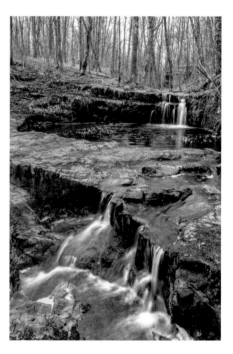

Above left: Immersed within the Blue Hills along the Ice Age Trail, Rock Creek spills over a ledge into a shallow kettle moraine known as Devil's Kettle. This waterfall is north of Weyerhaeuser in Wilkinson.

Above right: The kettle swirls around as it rolls to the left and whirls to the right, creating a tranquil display of multiple tiers. Each separate stream coalesces back into Rock Creek, where it continues onward until it permeates the ground downstream.

GEORGE LADD CREEK

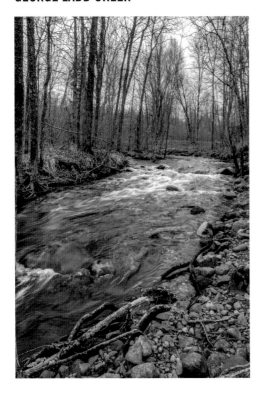

In the northeastern corner of the county, George Ladd Creek flows through secluded woodlands. This shallow Creek displays a small set of rapids before emptying into the Flambeau River.

GREENWOOD PARK

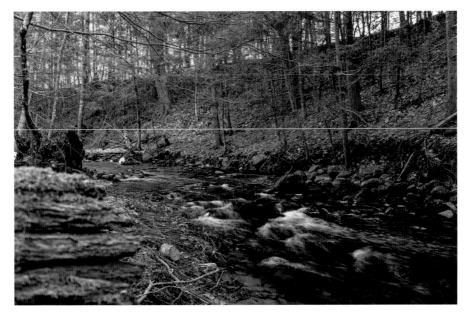

Greenwood Park in Ladysmith features a winding brook that ripples through a small wooded area. I often look for unmarked water flows by researching topography maps. Smaller streams commonly exist in ravines and sometimes exhibit waterfalls.

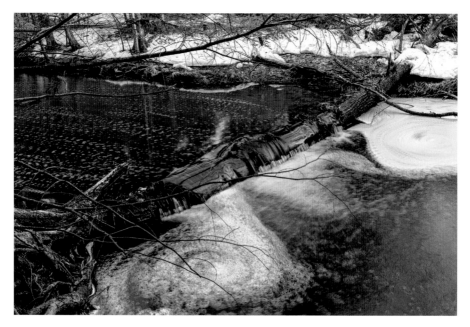

In this image, the brook flows over a fallen tree. The swirling pattern in the water is the result of stacking several photos together as one.

JOSIE CREEK

MAIN CREEK

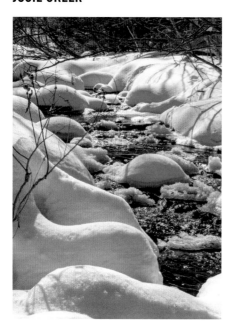

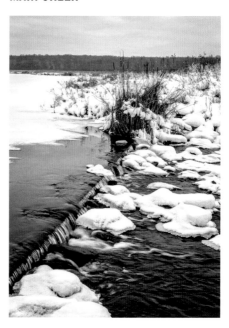

Above left: Josie Creek is a small babbling brook that flows through Josie Creek County Park. It converges with the Flambeau River.

Above right: Main Creek begins as an outflow from McGee Lake. The Creek continues onward through forests and farmlands downstream.

MIDDLE FORK MAIN CREEK

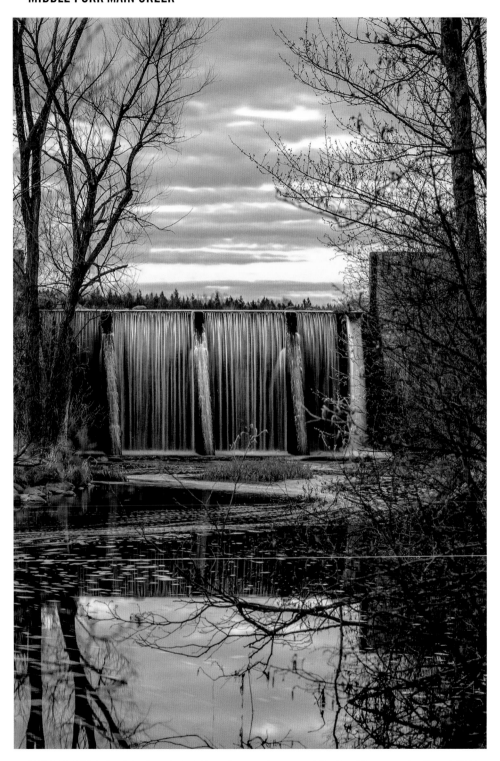

Middle Fork Main Creek begins at Lake LaVerne between Ingram and Hawkins. This reservoir spillway is hidden down in the ditch line. Take a glance from Highway 8 while driving by.

MEADOWBROOK CREEK

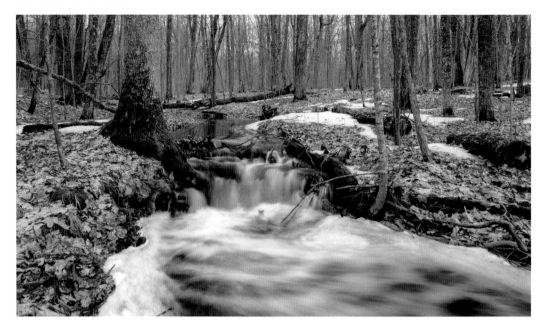

Meadowbrook Creek is an intermittent stream that winds its way through Copper Park in Grant Township, south of Ladysmith.

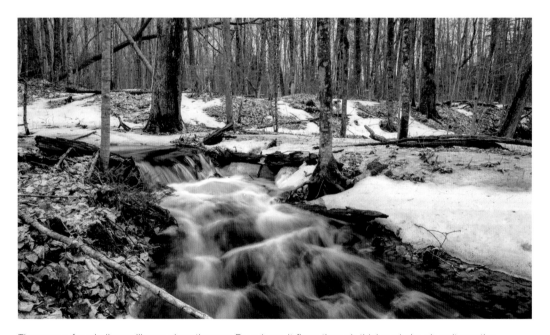

There are a few shallow spillovers along the way. From here, it flows through thick underbrush as it empties into the Flambeau River.

QUARRY PARK

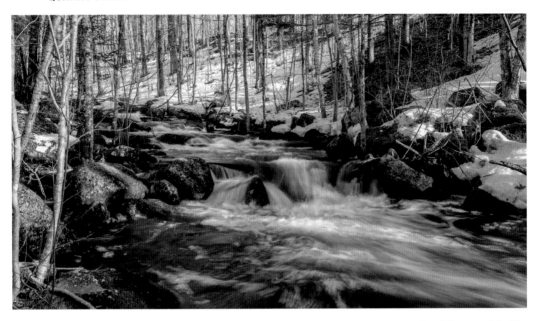

Quarry Park is north of Tony near the Big Falls Dam. This spring-fed stream produces a series of short waterfalls. The first drop is only a short hike upstream. This evanescent flow is most prevalent during the springtime or after heavy rains.

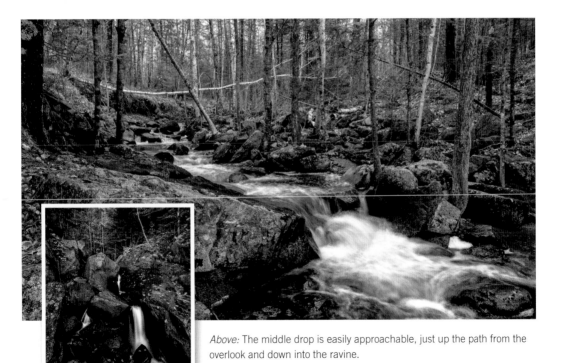

Above: The middle drop is easily approachable, just up the path from the overlook and down into the ravine.

Left: The final drop is more difficult to view as the water pours over a heap of large boulders down into the Flambeau River.

ROCK CREEK

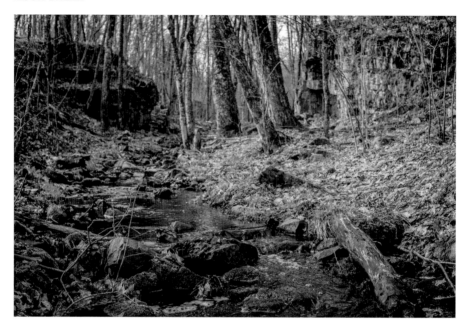

Rock Creek flows through the Rusk County Forest. This narrow stream continues easterly and lightly tumbles over and under rocks on its way to Devil's Kettle.

SIGNE FALLS

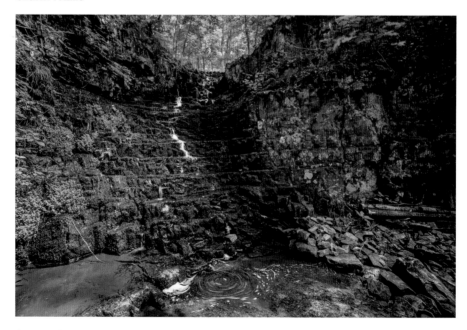

Concealed within the Blue Hills lies an ancient spectacle. Springwater trickles down into a narrow gully. Carl Gundersen found this waterfall on his property and named it after his wife, Signe. After the Gundersen's passed away, the land became the property of the Rusk County Forest. Signe Falls is spring-fed and flows into Rock Creek. This waterfall is also known as Gundy's Falls.

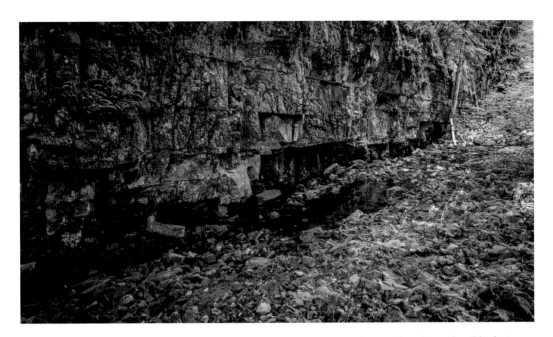

Accessing the falls is a long and unsteady hike upstream. At Gundy's Canyon, there is a rock wall I refer to as a gravity hill. A gravity hill is an illusion in the landscape where water appears to flow uphill. This result is from the angles of the surrounding landscape. It is fascinating to watch the water seemingly flow in reverse. There are places in Rock Creek where the water flows beneath piles of crumbling pipestone. This type of rock is very soft and looks like piles of bricks. Signe Falls occurs on an offshoot of Rock Creek to the right of Gundy's Canyon.

Viewing down into the gully gives perspective on the entire length of the water's descent. This landform can be a challenge to access through dense underbrush and rocky terrain. Plan to devote at least four hours for your hike, two hours in each direction. Shortcuts are possible but involve crossing through private property. I petitioned to have this region become a State Natural Area, except it does not meet the criteria. This place should be respected and protected. It is also one of the most remote waterfalls in the state. During summer, the water reduces to barely a trickle. There are bears here and plenty of wood ticks, too.

SWIFT CREEK

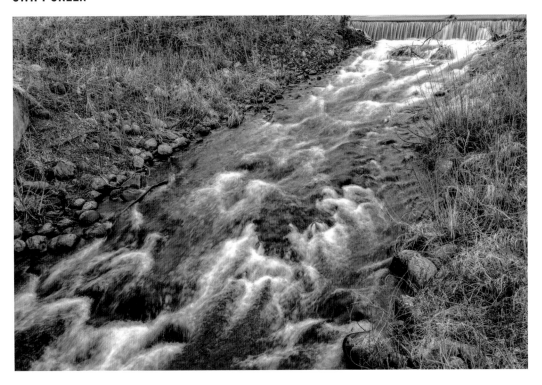

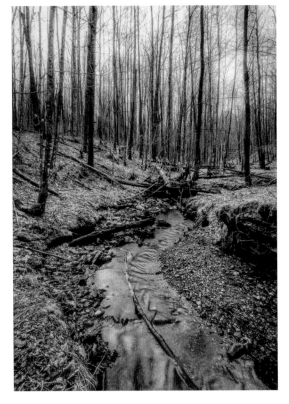

Above: Swift Creek emerges from the spillway at Island Lake and flows into marshy wetlands. I stood behind the guardrail to capture this image. The traffic on Highway 40 moves faster than the water, but the spillway is worth a glance while crossing the bridge.

Left: This unnamed rivulet emerges from higher elevations in the Blue Hills to join Devil's Creek downstream.

3

AVERTED WATERS

Several cities and towns in Wisconsin contain "Falls" in their name. These locations feature dams where natural waterfalls once flowed undisturbed. These include Black River Falls, Cato Falls, Cedar Falls, Chippewa Falls, Clam Falls, Jim Falls, Menomonee Falls, Park Falls, Pigeon Falls, Oconto Falls, River Falls, Rock Falls, Sheboygan Falls, and St. Croix Falls.

The following set of images include mills and scenic outflows from various dams across the state. According to the Wisconsin Department of Natural Resources, there are approximately 3,900 dams located throughout the state, each with varying degrees of visual appeal. Here, I will present some of the more memorable and picturesque places I've encountered in recent years.

COLTON FALLS ON THE TOTAGATIC RIVER

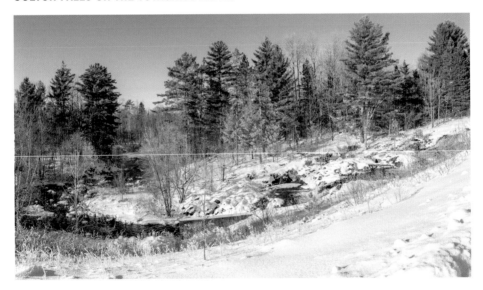

Colton Falls flows through private property in Chittamo. This outflow is viewable from the dam road as it exits Colton Flowage. The spillway descends westward over three tiers before continuing northward as the Totagatic River.

DELL'S MILL

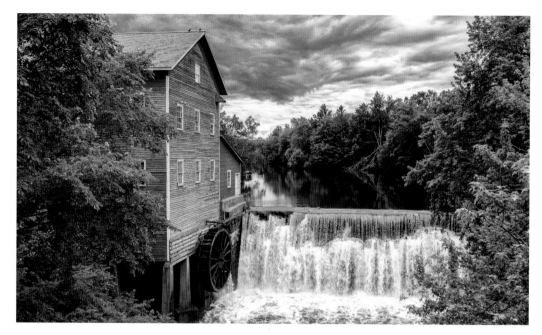

Dell's Mill and waterfall in Augusta is a state-wide favorite. Although the result of this waterfall is the damming of water, this dam will not disappoint. It is one of the most scenic in the state. This waterfall is also known as Augusta Falls, seen here before the restoration of the leaking dam. The original construction of the dam began in 1919 and held strong for nearly 100 years. The failing condition of the original dam gave a more natural appearance to the waterfall. New construction was completed in 2018.

DOUGLAS MILL POND

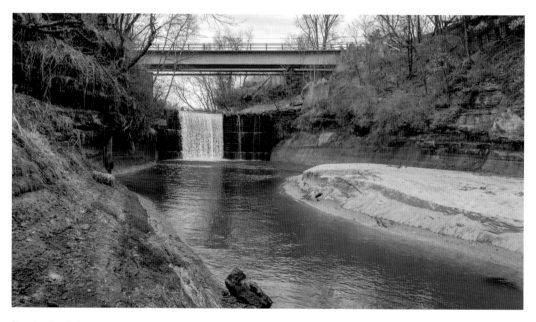

Douglas Creek features a spillway beneath a county road bridge in Melrose.

FALLS CITY FALLS

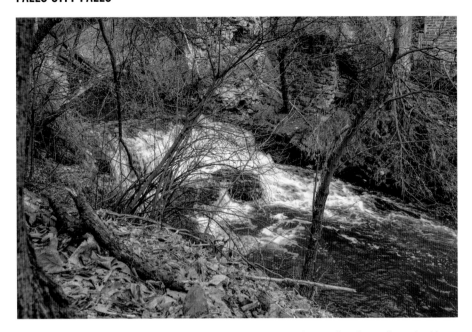

Falls City Falls in Falls City. This cascading torrent jettisons under a collapsing walkway beside an abandoned watermill.

JIM FALLS ON THE CHIPPEWA RIVER

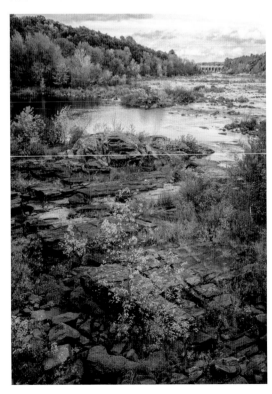

Jim Falls presents a series of rapids between two dams. The water levels are regulated and usually low enough to reveal small rapids. The old county road Y bridge offers a spectacular view from overhead.

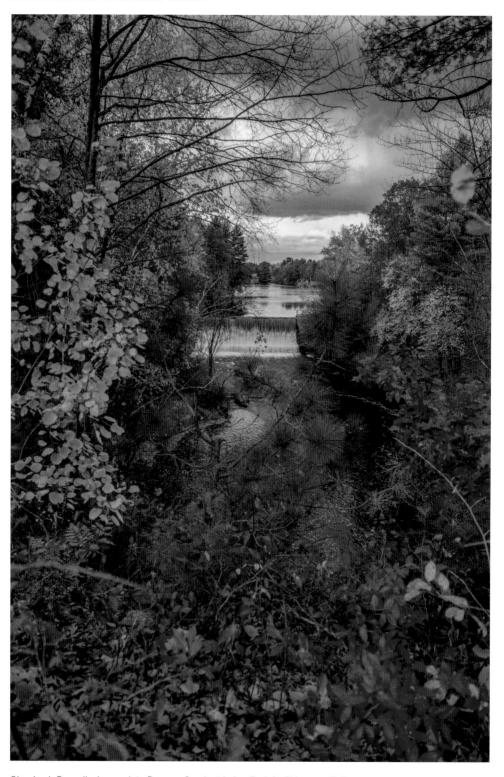

Glen Loch Dam discharges into Duncan Creek at Irvine Park in Chippewa Falls.

GRANDFATHER FALLS ON THE WISCONSIN RIVER

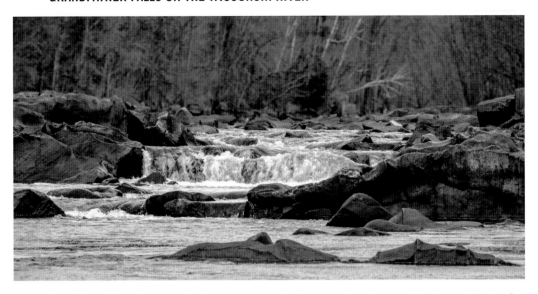

Grandfather Falls is the result of a diversion dam on the Wisconsin River. The elevation drops eighty-nine feet over the length of a mile. Massive boulders line the riverbed and produce a series of less-than-spectacular rapids near Merrill.

HYDE'S MILL

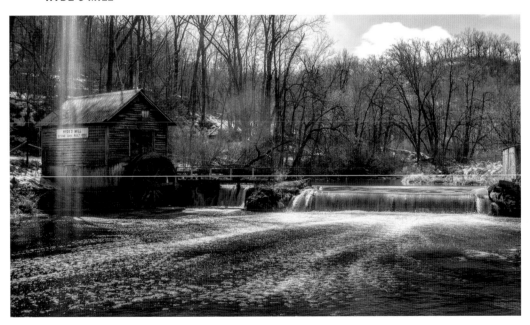

Hyde's Mill in Ridgeway is on private property and viewable from the county road bridge. This historical watermill was built in 1850 and comparable in size to a woodshed.

MILL CREEK

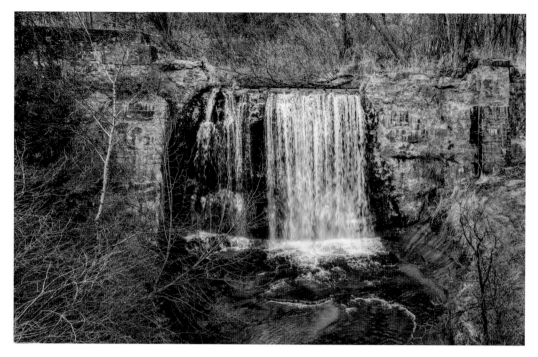

Mill Creek in North Bend plunges over the remnants of an old mill. The water continues to flow under a bridge, where it falls unobstructed. This impressive spillway often takes the namesake North Bend Falls.

NORTH BEND FALLS ON MILL CREEK

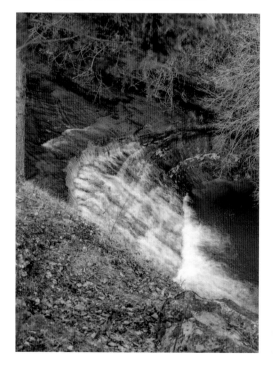

However, Mill Creek naturally falls as North Bend Falls on the south end of the bridge. This waterfall is tough to view as it rushes away into areas of private property.

MERRILLAN FALLS

Merrillan Falls in Merrillan is among the prettiest of spillways. The water also falls over a natural mound of rocks on the far bank of the river. I often enjoy making a pit stop here on my way to the southern part of the state.

ORIENTA FALLS ON THE IRON RIVER

Orienta Falls spills into a quarry in the sparsely populated township of Orienta. These falls are not viewable from the top side. There is a pathway with a dangerous descent to the right of the parking area. There is no stairway, only a rope and slippery orange mud with several boulders to navigate down into the quarry. If you decide to descend the embankment, proceed with caution. As with most of these places, you can find your way down, but getting back out can be more of a challenge. Also worth noting, there is no cell phone reception down in the quarry.

ROCK DAM ON HAY CREEK

Rock Dam displays a cascade like a curtain of water as it falls into Hay Creek near Willard. Hay Creek proceeds onward with a sloping descent featuring a few short drops along the way.

Frozen groundwater seepage appears as a curtain of blue icicles dangling from an overhang along Hay Creek.

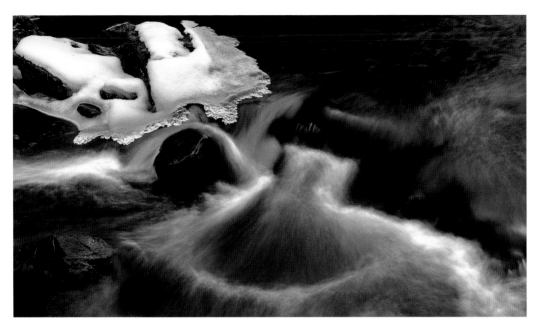

There are a few small rapids behind the campsites at Rock Dam County Park. Hay Creek merges with the South Fork Eau Claire River about a mile downstream.

SAXON FALLS DAM ON THE MONTREAL RIVER

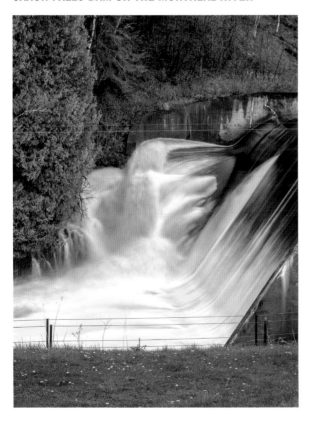

Saxon Falls Dam exhibits a thunderous deluge when the floodgates are open. This powerful barrage of fast-moving water is most prevalent during the spring.

STAR LAKE DAM ON DUNCAN CREEK

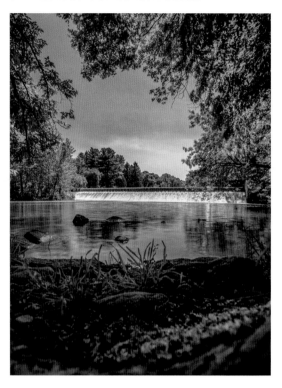

Star Lake Dam on Duncan Creek as seen from Marshall Park in Chippewa Falls.

YELLOW RIVER DAM

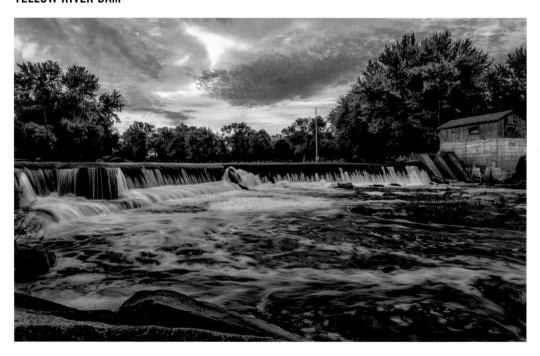

The Yellow River Dam in Cadott presents a scenic section of the Yellow River and is favorable for fishing.

WILLOW CREEK FLOWAGE NUMBER 1

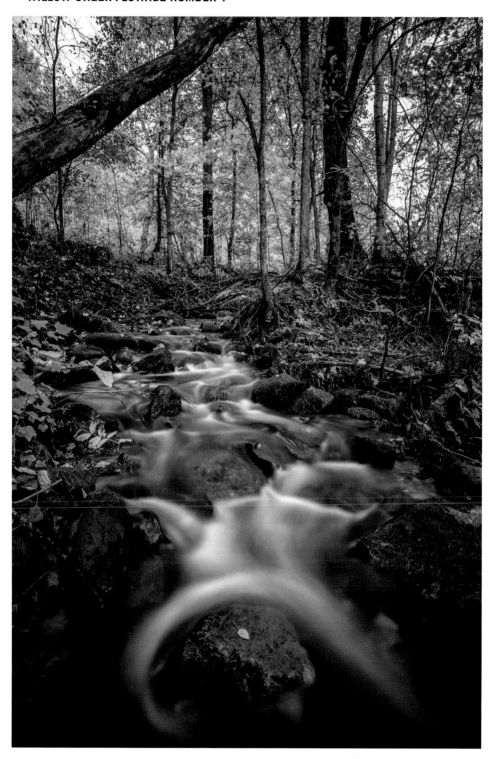

Willow Creek presents an occasional overflow from "Willow Creek Flowage Number 1." The lake overflows and trickles down an embankment before rejoining the outflow from the reservoir.

4

WATERWAYS BY COUNTY

The following section contains valuable information as a quick reference for waterfalls by county. These destinations reside along various waterways throughout the state. To save space in this publication, photos for the following locations will not accompany the descriptions unless already featured in previous chapters. This comprehensive list culminates many years of personal research and travels.

ADAMS COUNTY

White Creek is an unincorporated community in the town of Easton with an abandoned mill over a turbulent stream. Witches Falls at Witches Gulch along Gulch Creek is a slot canyon in Wisconsin Dells. Boardwalks traverse the stream as water flows beneath the walkway. Witches Falls is only accessible from boat tours on the Wisconsin River.

ASHLAND COUNTY

Copper Falls State Park in Mellen features Brownstone Falls, Copper Falls, Red Granite Falls, and Tyler Forks. Morgan Falls is within the same vicinity as Springbrook Falls in the Chequamegon National Forest. My first and only attempt to find Springbrook Falls was unsuccessful. The forest roads were impassable from recent storms with many bridge washouts.

BAYFIELD COUNTY

A brook trickles through the Big Ravine in Bayfield. Big Rock Rapids on the Sioux River exhibits a sloping mound of water near a campsite. Houghton Falls and Echo Dells is a must-see in Washburn. Lost Creek Falls is a long hike near Cornucopia. The Iron River passes through a quarry at Orienta Falls. Siskiwit Falls is on the Siskiwit River in Cornucopia. Twin Falls is on Larson Creek in Port Wing.

BROWN COUNTY

Baird Creek features numerous diminutive drops. Fonferek's Glen is in Green Bay with Kittle Falls down the road on private property. Lancaster Creek displays small rapids along Mountain Bay State Trail. Wequiock Falls is on Wequiock Creek northeast of Green Bay.

BUFFALO COUNTY
Tamarack Creek conceals a waterfall in the Modena countryside. This waterfall lies between farmlands and inaccessible unless permissible by the owners.

CALUMET COUNTY
High Cliff State Park has a waterfall along the Lime Kiln Trail.

CHIPPEWA COUNTY
Brunet Falls in Cornell is no longer in existence. Like many other falls along the Chippewa and Flambeau Rivers, the construction of dams now harnesses their power. Duncan Creek in Chippewa Falls displays several small rapids. Glen Loch Dam spills into Duncan Creek at Irvine Park in Chippewa Falls. Jim Falls on the Chippewa River presents a series of rapids between two dams. Lake Wissota spills into the Chippewa River at the Riverview Reserve. Little Falls is no longer in existence due to the dam on the Holcombe Flowage. The side road following the Chippewa River has a considerable drop in elevation as it discharges from Lake Holcombe. I can only imagine these "little falls" were a significant height at one time. There is an outflow from Star Lake Dam at Marshall Park in Chippewa Falls. Willow Creek overflows from Willow Creek Flowage in Birch Creek. Also, the Yellow River at the Dam in Cadott displays an elegant overflow.

CLARK COUNTY
Rock Dam at the Rock Dam County Park spills into Hay Creek in Willard. Hay Creek features a few rapids and a short waterfall.

COLUMBIA COUNTY
Dates Millpond is beside a dam on the Fox River in Portage.

CRAWFORD COUNTY
The Kickapoo River in Gays Mills highlights a historical dam on the Kickapoo River. The weir extends from the museum and has a spillway beside Robb Park.

DANE COUNTY
Wingra Dam in Madison has a short spillway.

DODGE COUNTY
Danville Millpond has a spillway over the dam on the CrawFish River.

DOUGLAS COUNTY
Amnicon Falls State Park on the Amnicon River in South Range features Amnicon Upper and Lower, Now & Then, and Snake Pit. Pattison State Park in Superior showcases Big Manitou on the Black River and Little Manitou upstream. Copper Creek Falls is near

impossible to reach in the state forest near Superior. The Bois Brule River features a series of rapids and ledges, including Lenroot Ledges, Mays Ledges, and Shale Falls. This river is favorable for outdoor recreation.

DUNN COUNTY
Devil's Punchbowl is in Menomonie. Falls City Falls is in the ghost town of Falls City. The Red Cedar State Trail near Dunnville features a few runoffs. There is also Tripp Falls at Tripp Falls Ravine in Menomonie.

EAU CLAIRE COUNTY
Big Falls is on the Eau Claire River in Seymour. The Dell's Mill is on the Dells Mill Pond in Augusta. Hamilton Falls presents a ledge on the North Fork Eau Claire River in Wilson Township. Little Niagara Creek falls into the Chippewa River near UWEC. Rod & Gun Park has eight spring-fed ponds with flowing channels alongside Half Moon Lake in Eau Claire.

FLORENCE COUNTY
Big Bull Falls is not so big on the Popple River in Florence. Breakwater Falls is a sixty-foot emanation tumbling from a dam on the Pine River. Jenning's Falls is a series of rapids on the Popple River. LaSalle Falls is on the Pine River in Florence. Little Bull Falls on the Popple River is inaccessible by land. This section of the river is only reachable by paddle or drone. The Pine River features Chipmunk Rapids and Pine Rapids, with miles of whitewater. Myers Falls on the Pine River rages through the Nicolet National Forest. The Popple River Features Big Bull Falls, Jennings Falls, Washburn Falls, and plenty of whitewater along the way.

FOREST COUNTY
Armstrong Creek flows underneath a historical footbridge off the Old 101 Road in the small community of Armstrong Creek. The Peshtigo River also presents whitewater along its winding stretch throughout the county.

GRANT COUNTY
Wyalusing State Park near Prairie Du Chien features three notable waterfalls, each similar with thin wispy rivulets of water. These horsetail-type waterfalls shower down from dramatic heights into cavernous hollows. Hiking along the Sand Cave Trail leads to the falls at both Little Sand Cave and Big Sand Cave. Hiking the Sugar Maple Nature Trail leads to the falls at Pictured Rock Cave.

IOWA COUNTY
Big Spring Falls is spring-fed and tumbles down a hillside near Highland. Governor Dodge State Park in Dodgeville features a few waterfalls and the spillway from Cox Hollow Lake. The most well-known waterfall at this park is Stephans Falls. Cox Hollow Falls tumbles

underneath a footbridge. It's a short walk from the parking lot on the east end of Cox Hollow Lake. Hyde's Mill resides in Ridgeway.

IRON COUNTY

Foster Falls is on the Potato River north of Upson. Gile Falls is the result of a sharp-angled turn on the West Fork Montreal River in Montreal. Interstate Falls is on the Montreal River in Hurley. Kimball Falls is a series of rapids on the West Fork Montreal River. Lake of the Falls in Mercer is the beginning of the Flambeau River. Little Balsam Falls is not easily accessible on the Tyler Forks River. Little Gabe Falls is on Mud Creek in Saxon. The Montreal River features a series of rapids and falls. Peterson Falls on the Montreal River in Hurley is upstream from Interstate Falls but only accessible through Michigan. Potato River Falls is the largest waterfall along the Potato River. This River also features various sections of subsequential whitewater. Tyler Forks features numerous cascades and rapids, including Tyler Forks Dells. Rice Lake Falls is northeast of Lake of the Falls near Mercer. Rouse Falls on Rouse Creek is in the outback of Iron County. Saxon Falls and the Saxon Dam are both on the Montreal River. Spring Camp Falls on the West Fork of the Montreal River is in Pence. Superior Falls is on the Montreal River. Upson Falls is on the Potato River in Upson. The outflow at Weber Lake gains momentum and produces a tumbling stream along the road. Willard Falls is on the Potato River in Gurnee. Wren Falls is a wild adventure on the Tyler Forks River.

JACKSON COUNTY

Douglas Mill Pond produces an elegant spillway into Douglass Creek. Hatfield Dam has a few waterfalls and rapids on the outflow of Lake Arbutus. Lost Falls is on Roaring Creek along with Roaring Creek Falls further downstream. Both are in Irving. Merrillan Falls is along the main highway in Merrillan. North Bend Falls on Mill Creek in North Bend features two waterfalls. The WI-54 bridge provides easy viewing of both the spillway and the waterfall further downstream. Perry Creek Falls is on Perry Creek in the Black River State Forest in Brockway. Robinson Creek features a short drop viewable from the bridge on Kelly Road. Polly Falls presents a six-foot plunge further downstream but flows through private property.

KENOSHA COUNTY

The Pike River at Petrifying Springs Park has a few rapids in Kenosha.

LA CROSSE COUNTY

Riverside Park in La Crosse displays an elaborate water feature, resembling a natural waterfall beside the La Crosse River.

LINCOLN COUNTY

Grandfather Falls is the result of a diversion dam on the Wisconsin River north of Merril. Prairie Dells displays a series of rapids along this unique section of the Prairie River east

of Merrill. Ripley Creek has a few short rapids at Camp New Wood Park. Following the Ice Age Trail leads to Grandfather Falls upstream. Spirit Falls is on the Spirit River in Spirit Falls.

MANITOWOC COUNTY
Devils River Falls is in Maribel (shown on cover). The East Twin River features a small cascade (also known as Mishicot Falls). Lower Cato Falls is on the Branch River in Cato. Nachtwey Falls on the Neshota River presents a ledge with a shallow drop in elevation. Further downstream additional rapids merge with the Devil's River. Spring Cave Falls is a freshwater aquifer flowing from a cavern in Maribel.

MARATHON COUNTY
Amco County Park features small rapids when the water is low along the Big Rib River in Athens. The Big Eau Pleine River exhibits a series of rapids near Abbotsford. Downstream is Big Rapids County Park and also March Rapids Park near Stratford. Dells of the Eau Claire River presents a series of rapids near Aniwa. There is also Rib Falls on the Rib River.

MARINETTE COUNTY
Big South Falls on the South Branch Pike River is inaccessible on private property in Amberg. Bull Falls is on the Pike River in Amberg. Carney Rapids is on the Pike River. Cauldron Falls is the outflow from the Cauldron Falls Reservoir near Crivitz. Chipmunk Falls/Rapids is on the North Branch Pike River. Dave's Falls is on the Pike River in Amberg. Eagle Creek is a short tributary of the Peshtigo River, featuring a small cascade between Silver Cliff and Athelstane. Eight Foot Falls is downstream from Twelve Foot Falls. Eighteen Foot Falls is on the Pike River in Dunbar, while Four Foot Falls is barely a waterfall on the Pike River. Horseshoe Falls is also on the Pike River. High Falls at High Falls Dam is on the Peshtigo River. Subsequently, Johnson Falls occurs at Johnson Falls Dam. Both dams are north of Crivitz. Kremlin Falls is on the South Branch Pemebonwon River. Long Slide Falls is on the North Branch Pemebonwon River. McClintock Falls is at McClintock Park in Athelstane.

The Peshtigo River has a series of rapids including Wilson Rapids, Roaring Rapids & Jerry Chute. There is plenty of whitewater for thrill-seekers. Piers Gorge is on the Menominee River in Niagara. Quiver Falls is on the Menominee River in Kremlin. The Rat River features a series of rapids before merging with the Peshtigo River near Silver Cliff. Sand Portage Falls is on the Menominee River in Niagara. Smalley Falls is on the North Branch of the Pemebonwon River. Strong Falls is at Goodman Park on the Peshtigo River. A parking permit is required here. There are plenty of hiking trails, and it's easily accessible. Taylor Rapids is a short distance upstream and similar in appearance. Three Foot Falls is downstream from Veterans Falls. Thunder River Falls and South Fork Thunder River Falls are near one another in Stephenson Township. Both waterfalls appear to flow through private lands. Lastly, there is Veterans Falls on the Thunder River.

MARQUETTE COUNTY
Granite Quarry Falls at the Daggett Memorial Park in Montello has an elaborate water feature that mimics a natural waterfall.

MENOMINEE COUNTY
The Wolf River features Big Smokey Falls, Big Eddy Falls, Dells of The Wolf River, Duck Nest Falls, Keshena Falls, Pissmire Falls, and Sullivan Falls. The Wolf River also highlights several rapids and whitewater along its swath through the Menominee Reservation. These Rapids include Saint Claire, Big Slough Gundy, Little Slough Gundy, Little Sheen, Burnt Point, Ninemile, Oxbo, Cedar, Hemlock, Sherry, Larzelere, Crowle, Horse Race, Twenty Day, the Ledge, Garfield, Hanson, Gilmore's Mistake, Burnt Shanty, and Shotgun Eddy, ending at Wolf Rapids. Other falls in this county include Evergreen Falls on the Evergreen River. Bear Trap Falls, Peavey Falls, and Rainbow Falls flow through private lands. Wayka Falls is on the West Branch Wolf River.

MILWAUKEE COUNTY
The Milwaukee River features a spillway at Kletzsch Park in Glendale and a ledge on the River at Estabrook Park in Shorewood. Oak Creek Millpond in South Milwaukee highlights an eye-catching spillway along Oak Creek Parkway. Mallard Lake Dam presents an outflow into Tess Corners Creek at Whitnall Park in Franklin.

MONROE COUNTY
The Little Lacrosse River flows through Amundson Park in Sparta. Small rapids are present near the footbridge. Trout Falls on the La Crosse River features a waterfall near Fort McCoy.

OCONTO COUNTY
North Branch Oconto River features small rapids, the most notable being Bagley Rapids in Mountain. Also, Waupee Creek Rapids along Waupee Creek is within the vicinity.

ONEIDA COUNTY
Cedar Falls on Kaubashine Creek near Hazelhurst. Noisy Creek is a tributary of the Wisconsin River. I cannot confirm if any rapids exist, but I like the sound of it.

OUTAGAMIE
The Fox River descends with a series of gradual slopes that appear as rapids after flowing from numerous reservoirs in Kaukauna.

OZAUKEE COUNTY
Cedar Creek displays a modest waterfall at Cedar Creek Park downtown Cedarburg. The Milwaukee River courses through Grafton and presents a spillway with rapids downstream. Both are viewable from the bridges at Bridge Street and Falls Road. Sauk Creek flows through a series of short ledges at the Sauk Creek Nature Preserve in Port Washington.

PIERCE COUNTY

Kinnickinnic State Park on the Kinnickinnic River features an off-trail waterfall where the Kinnickinnic meets the St. Croix in River Falls.

Glen Park offers two waterfalls on the South Fork Kinnickinnic River and the dam waterfall at Lake George in River Falls.

Pine Creek features a few cascading drops along the countryside of Maiden Rock. The Trimbelle River has a few rapids at the Public fishing areas along the Creek.

POLK COUNTY

Buttermilk Falls in Osceola is accessible at the Standing Cedars Trailhead. Cascade Falls on Osceola Creek has street parking and is accessible down a maze-like staircase. Giger falls, along with Osceola Falls, are on the topside at the Gristmill Park. Clear Lake Park in Clear Lake has a shallow Creek in a rocky glen. Osceola Bedrock Glades State Natural Area has hiking trails along a stream with a few minor drops along its gradual descent to the St. Croix River. Silverbrook Falls is at the southern edge of Interstate State Park in St. Croix Falls. It is also accessible down the Copper Mine Trail.

PORTAGE COUNTY

Stedman Wayside Park along the Tomorrow River features a scenic display of rapids south of Amherst.

PRICE COUNTY

Big Falls is on the Jump River in Kennan.

RACINE COUNTY

The Root River in Racine displays a few falls downstream from the Root River Dam.

RICHLAND COUNTY

Orion Falls is along the road at the Orion Mussel state nature area.

RUSK COUNTY

Please view the previous chapter, Creeks of Rusk. Additionally, Red Canyon Falls trickles thirty feet as a horsetail waterfall in the Blue Hills of Murry Township. This waterfall is most active during the spring when snow transforms into meltwater. The hike to this location is over three miles round trip through muddy trails and bogs. My first and only attempt to locate this waterfall was unsuccessful. When I reached Big Weirgor Creek, I knew I went too far in the wrong direction. If you are interested in this waterfall, spring meltwater should produce an exhilarating display.

SAUK COUNTY

Baxter's Hollow and Durward's Glen are both in Baraboo. East Bluff Falls and Fern Dell Gorge are both at Devil's Lake State Park. Honey Creek trickles through Honey Creek State Natural Area, Leopold Memorial Woods, and Pine Hollow State Natural Area. Lake Redstone Falls in LaValle is a raging waterfall where Big Creek channels into Lake Redstone. Parfrey's Glen State Natural Area displays rock formations along the lower edge of the Ice Age Trail and exhibits a cascading stream. Pewit's Nest is on Skillet Creek in Baraboo. Seeley Creek spills from Lake Seeley at Devil's Lake State Park. Other falls exist throughout this expansive park.

SAWYER COUNTY

Bellile Falls in Radisson is more like rapids on the Chippewa River. The Brunet River in Winter features a series of rapids. The Flambeau River features some rapids, including Wannigan Rapids, Flambeau Falls Rapids, Cedar Rapids, and Beaver Dam Rapids. Little Falls is on the South Fork Flambeau River. More rapids exist further downstream, including Scratch Rapids, Gunnar Rapids, and Otter Slide. Ojibwa State Park in Ojibwa has an unnamed spring flowing from the hillside. Pipestone Falls on Pipestone Creek is north of Radisson. Also, the Teal River in Hayward has some rapids when the water is low. Satellite images indicate a significant drop in elevation with a waterfall enclosed by private lands.

SHAWANO COUNTY

Caroline Millpond and Dam is on the South Branch Embarrass River. Freeman Falls is on the Red River in Gresham. Gilmer Falls, also known as Ziemer's Falls is also on the Red River in Gresham. Hayman Falls is near Marion on the South Branch Embarrass River. Little Bull Falls is on the Red River in Gresham. Tilleda Falls is an outflow from Tilleda Pond in Bowler.

SHEBOYGAN COUNTY

Mill Pond Park is on the North Branch of the Milwaukee River. The Sheboygan River features a series of short drops visible from the bridge in Johnsonville.

ST CROIX COUNTY

Apple River Falls in Somerset is the result of the dam at Apple Falls Flowage. This area is inaccessible and owned by the power company. Little Falls and Pike Hole Rapids are also on the Apple River. The Dalles of the Saint Croix River exhibits swift-flowing rapids through rocky dalles. The Saint Croix River is the natural border between Minnesota and northwestern Wisconsin. Willow Falls State Park offers Willow Falls on the Willow River in Hudson.

TREMPEALEAU COUNTY

Horseshoe Falls at Perrot State Park in Trempealeau features seasonal runoff that trickles down from Brady's Bluff into a hollow. Pigeon Falls has a series of rapids downstream from the dam along the Pigeon River.

VERNON COUNTY

The Hammer and Klopfeisch Park in Hillsboro displays some rapids downstream from a dam. Jersey Valley Lake in Westby is where the West Fork Kickapoo River flows through a rocky gorge. Kickapoo Valley Reserve State Natural Area in Ontario features groundwater outflows from sandstone rock formations. There are some smaller rapids on the North Fork Bad Axe River at the Eagle Eye State Natural Area near Viroqua. Similar rapids exist further upstream on the Springville Branch Bad Axe River in the Duck Egg County Forest.

VILAS COUNTY

Little Horsehead Lake spills over a short ledge of boulders into the South Branch Presque Isle River in Presque Isle.

WALWORTH COUNTY

Honey Creek State Natural Area is on Honey Creek. White River Park features small rapids on the White River in Lyons.

WASHBURN COUNTY

The Totagatic River features a series of falls along its winding swath throughout the densely wooded areas and marshy wetlands, including Buck Falls, Colton Falls, and High Falls. Yarnell Creek Falls is a short hike down the Tuscobia State Trail from county Y near Birchwood.

WAUKESHA COUNTY

Menomonee Falls is home to a picturesque outpouring from the dam at Millpond Park in the downtown area. There is also Paradise Springs in Eagle.

WAUPACA COUNTY

Big Falls and Little Falls on the Little Wolf River comprise a series of rapids. Brainard's Bridge Park in Waupaca has rapids on the Waupaca River. Keller Lake County Park in Big Falls manifests a tumbling emanation of water from Keller Lake Dam. Waupaca Falls on the Waupaca River swoops under a bridge in downtown Waupaca.

WOOD COUNTY

The Yellow River in Arpin features a stair step-like spillway between Lake Kaunewinne and Lake Manakiki at Northwood County Park. The Wolf River features a series of rapids. Little Bull Falls on the Yellow River flows through private property in Pittsville.

5

FINAL THOUGHTS

Marinette County is the holder of the most waterfalls in the state, with Iron County at a close second place. All in all, Wisconsin is abundant with many waterways. Sometimes you need to explore for yourself to see what you might find. I know more are said to exist, but I chose not to include places if I could not confirm their existence. When a waterfall occurs in densely wooded areas or on private property, it can be hard to verify.

As thorough as my research and travels have been, my primary focus was to assemble a list of places as prospects for taking photos. As much as I would like to photograph all these locations, travel expenses and time are limiting factors. I have been to most, yet many of these destinations remain on my list.

I am not a conservationist nor affiliated with the DNR. I am just a photographer who enjoys exploring what nature has to offer. It was not my intention to share precise coordinates or to give step-by-step directions. Part of the fun is trying to find these destinations. I discovered many during my time as a contributing photographer for Google Maps. Most of the waterfalls within this work are corroborative with a simple online search. If you have difficulty finding more defined whereabouts, further information is often available through various visitor centers around the state.

On the next page: It doesn't end here. Many waterfalls exist around the Great Lakes Region. A few miles across the Wisconsin border into the Upper Peninsula of Michigan resides one of my favorite waterfalls, Gabbro Falls in Bessemer. No matter where you choose to explore, nature offers a plethora of possibilities!

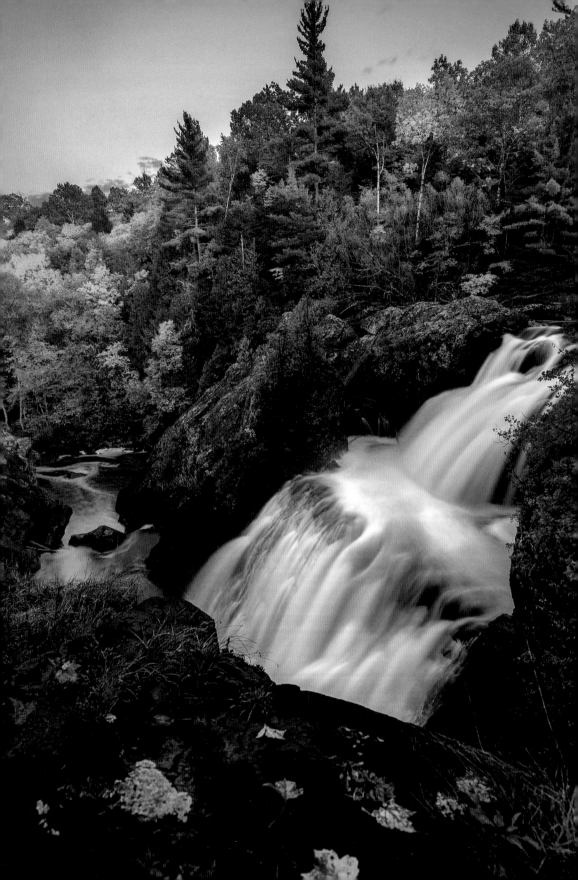